D1503713

BIRTH OF A WARRIOR

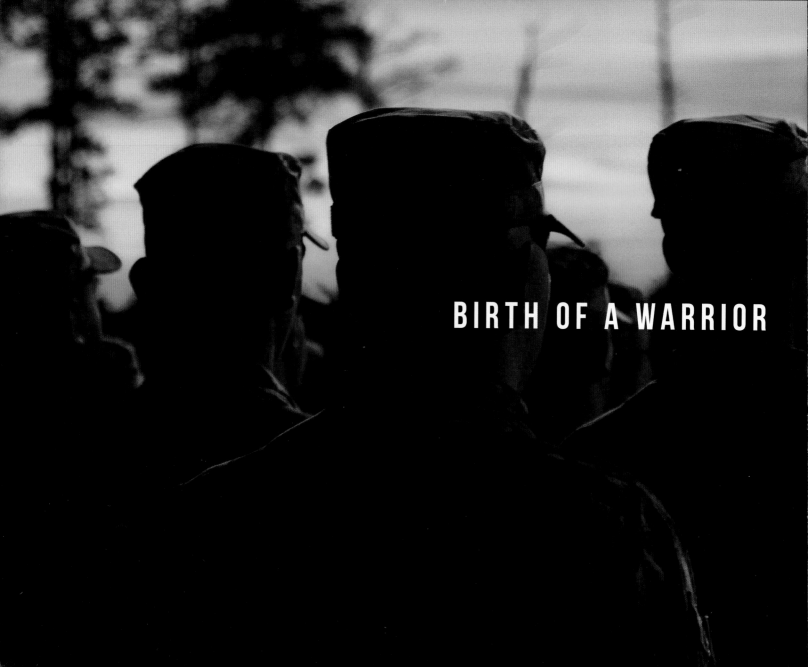

BIRTH OF A WARRIOR

TEN WEEKS IN BASIC TRAINING

RAYMOND MCCREA JONES

ForeEdge

ForeEdge
An imprint of University Press of New England
www.upne.com
Manufactured in the United States of America
Designed by Mindy Basinger Hill
Typeset in Chaparral Pro

For permission to reproduce any of the material in this book,
contact Permissions, University Press of New England, One Court Street,
Suite 250, Lebanon NH 03766; or visit www.upne.com

Library of Congress Cataloging-in-Publication Data

Jones, Raymond McCrea.
Birth of a warrior: Ten weeks in basic training / Raymond McCrea Jones.
 pages cm
ISBN 978-1-61168-764-4 (pbk.: alk. paper)—ISBN 978-1-61168-797-2 (ebook)
1. Fort Benning (Ga.)—Pictorial works.
2. Basic training (Military education)—United States—Pictorial works.
3. Soldiers—United States—Pictorial works.
4. United States. Army. Infantry, 47th. Battalion, 2nd. Delta
Company—Pictorial works. I. Title.
U294.5.F67J65 2015
355.5'40973—dc23 2014048838

5 4 3 2 1

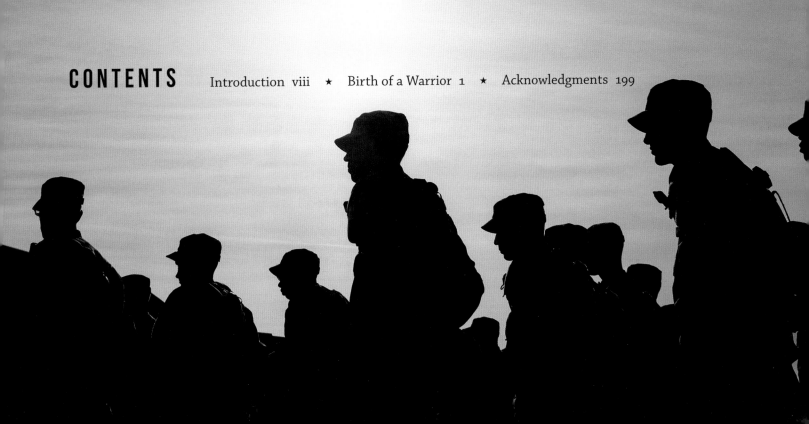

CONTENTS

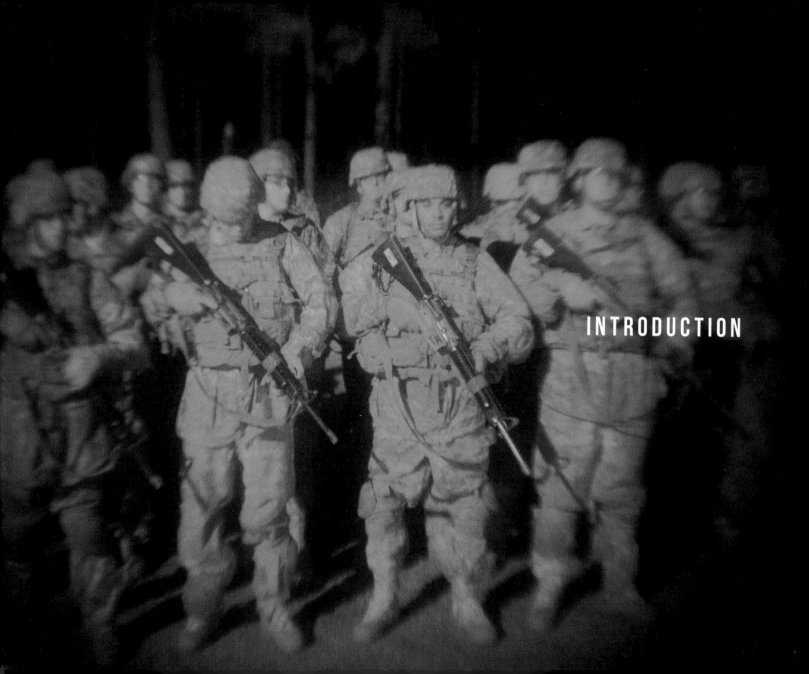

INTRODUCTION

Though my family hails from West Virginia, I was not cut out for life as a U.S. Army recruit on a base in South Georgia. My father was a Southern Baptist minister. He and his brother, both born in the early 1950s, miraculously missed the draft lottery of 1969. My father's father, a curmudgeonly veteran of World War II, was the closest thing I ever knew to a soldier—or war. Any retelling of a story about my grandfather must involve an impersonation of him saying "it's the damn government's fault" and his rendition of "O Tannenbaum" in German at Christmas time.

Although I do not come from a military family, somehow "the military" has always been an object of fascination, or perhaps bewilderment, in a way almost like a distant relative. I was instinctively curious and fascinated. It was this innate curiosity about any way of life other than my own that would establish the foundation for my career as a photographer.

When I was a child growing up in Chesapeake, Virginia, G.I. Joe was the pervasive boy's toy of my generation. We collected the action figures. Then we blew them up in the backyard with fireworks. Then we dug foxholes and played army, pretending to shoot each other with toy guns. Toy weapons were omnipresent and "playing" war was exhilarating.

My family was an anomaly in the working-class community we were a part of. Most dads worked at the navy shipyard in nearby Norfolk and would come home smelling of cigarette smoke, hands stained with grease. My dad was a minister and one of the few that did not have stories and scars from Vietnam.

But in 1990 my eight-year-old self was confronted by war in the most direct way yet. The Gulf War brought conflict to life with live news broadcasts as Americans witnessed the war unfold in living rooms across the country. I vividly remember watching the nightly news with my parents and seeing images of burning oil fields, bombings, and coalition troops in dramatic desert scenes from the Middle East. It was terrifying, shocking, and fascinating.

As I grew up and discovered my passion for photography and visual storytelling, I was further moved by images of conflict through the work of masters such as Robert Capa, Larry Burrows, and James Nachtwey. Although my own career has not led me to conflict zones,

their courageous work and that of countless other men and women has greatly influenced my life and career.

★ ★ ★

Fast forward through years in North Carolina, Philadelphia, Hartford, and New York to a cold February night in 2013, when I find myself standing on a charter bus at Fort Benning, Georgia, peering over the shoulder of a U.S. Army drill sergeant and into the faces of dozens of stone-cold young men. They had arrived from locations around the country to one of five army bases in the United States where civilians are trained to become soldiers. This was the beginning of *Birth of a Warrior* and the closest I had come yet to entering the military realm.

The drill sergeant's stiff-brimmed hat cut a perfect silhouette against the dim interior lighting on the bus. "This really is just like in the movies," I thought. I could make out details of faces and bits of individuality in the young men seated before me, small slivers of character that inform one's judgment about

another he's never met. But soon uniformity and discipline would be the order as the 162 recruits of Delta Company, 2nd Battalion, 47th Infantry Regiment embarked on a ten-week journey to be transformed from civilians to soldiers.

It was 2030 hours on February 27, 2013, the night of arrival for a new batch of recruits. Tomorrow would begin day zero and three long days of processing at 30th AG Reception Battalion before the ten weeks of brutal basic training.

Months of negotiation with the administration at Fort Benning had led me to this moment. What an amazing feeling it is to embark on a new long-term project that is full of challenges and possibilities. I was eager to begin. I couldn't communicate with the recruits, and although it isn't a fair comparison I felt as if we were in this together to some degree.

There are countless military photography projects documenting war zones and conflict, but my goal was to turn the perspective in the other direction and examine the genesis of a soldier's beginnings, the absolute birth.

I was assigned one unit to follow, Delta Company 2/47, with its 162 recruits. My goal was to be on location, "embedded" with the company for as much time as possible. I was given access to everything except exercises deemed too dangerous for a civilian. Using my skills as a journalist to build trust and work unobtrusively, I set out to document the journey.

To do this I photographed the same 162 soldiers day after day for ten weeks. This work is not meant to be a definitive picture of the step-by-step training soldiers receive, but it is instead meant to serve as a sort of snapshot of one group's journey along the way. Male and female army recruits are still trained separately, so my sliver of observation is even narrower in that I was only able to witness the journey of male recruits.

Several drill sergeants I talked to, however, hinted that major changes are on the horizon. It's a new army, they say. Gone are the days of screaming at and belittling recruits. The tactics of drill sergeants are now more carefully calculated and described with terms like "encouragement" and "motivation." After more than a decade at war there is a sense that the American military is turning a corner and no one knows what lies around the bend. New soldiers are no longer being immediately deployed for fifteen-month tours in a war zone like Iraq or Afghanistan in the mid-2000s. But while the army may be trying to polish its image and refine its practices, the fundamental mission remains the same: transforming civilians into soldiers—and it all begins with basic training.

★ ★ ★

"What are you smiling at?" the drill sergeant said. "Put those teeth away. I'm not your dentist!"

I couldn't help but be affected by the tension and anxiety coming off the recruits in waves. It was contagious and before I knew it I too was avoiding eye contact with the drill sergeants and trying my best not to get in the way or call attention to myself.

"How did I find myself here and why?" I found myself thinking. "I am *so* in over my head right now." These thoughts occur to me from time to time in the field photographing. When I feel these questions arise I know something is going right. It means I am exactly

where I need to be and I'm a part of something potentially eye-opening, something special. Those thoughts bring excitement and exhilaration. And that is why I drove hours upon hours back and forth between Atlanta and Fort Benning for ten weeks. That is why I gave up precious time with my wife and two young boys to stay in run-down hotels, sleeping for just three hours to awaken at 4 a.m. to take pictures. That is why I shot for entire days in the rain and wore the soles completely off my boots. That is why I'm addicted to exploring humanity through my photography.

Curiosity drove me to ask the simple question, "What makes someone want to become a soldier?" A hint of defiance led me to ask, "Well, what does it actually look like to transform a civilian into a soldier?" and "How does that affect someone's individuality?" The best way I know how to answer those kinds of questions is to set out on a visual journey with camera in hand, hoping to find some answers.

I asked myself so many questions during my ten weeks at Fort Benning. Why would you . . . ? What does that . . . ? How old is . . . ? How do they . . . ?

Open-ended questions I tried hard to ask myself honestly without any preconceived notions. And to answer, as best I can, with my camera.

Venturing into personally uncharted territories brings with it all sorts of emotions and opinions. But as an observer I am adamantly a human being first and a photographer second. Whether I'm photographing a celebrity, a Paralympic athlete, a corporate CEO, or a cancer-stricken young person, my job is not to make judgments about the people who graciously let me into their lives. My goal is not to uncover and shine a light on a person's flaws or make some self-aggrandizing political statement. I'm interested solely in what makes us tick—as individuals, as humans, as a culture. And it's the edges of society I find myself most powerfully drawn to. This is where hints of fanaticism arise and blend with qualities like obsession, awkwardness, and rebellion. The places where one person's badge of honor elicits uneasiness from passersby. If there's one realization I've made throughout my work examining fringe subcultures, it's that we're all profoundly different, but really we're all kind of the same.

To an outside observer, the military life is one such subculture. It has its own code, its own language, its own way of life. And that is how I approached this project. I saw something new to me. It was fascinating and I wanted to see more.

No matter how you feel about the military or whether or not you agree with its aims, methods, or leadership, one thing remains true: "the military" is made up of individuals just like you and me who are oftentimes working in dangerous situations and even putting their lives at risk to do their job. And that is exactly what being a soldier is, a job. Let's face it, the "great recession" has forced many Americans to confront hard times in ways they might not have considered before. We're going on seven years now and the economy still has not fully recovered. To many young men and women the army offers an opportunity for a steady paycheck, health care, and an education. For some, it also offers a kinship structure, something to belong to. For still others, America's wars of the past decade are a lure as ancient as civilization.

The military may be a hardened bureaucratic machine, but its foundation is made up of people, with names and families and stories. Ironically, the nature of this project and of basic training for that matter did not allow me the luxury of sitting down and talking with privates one-on-one to hear their unique stories. It was all business for ten full weeks. But for me that is what makes this project special. From day zero, when recruits arrive in civilian clothes from all around the country, one witnesses 162 distinct individuals. And although that outward individuality is stripped to form a homogenous unit that functions with precision, that company is still made up of 162 minds and bodies with an infinite number of personal stories and experiences.

In the end I think my greatest takeaway from this project was the notion that civilians who make the choice to become soldiers are also becoming a part of a long-standing and insular community, with history, tradition, glory, sacrifice, and honor. This family of sorts may be large, and it certainly has its flaws, but the sense of camaraderie and community is indeed special and could be one of its most powerful weapons.

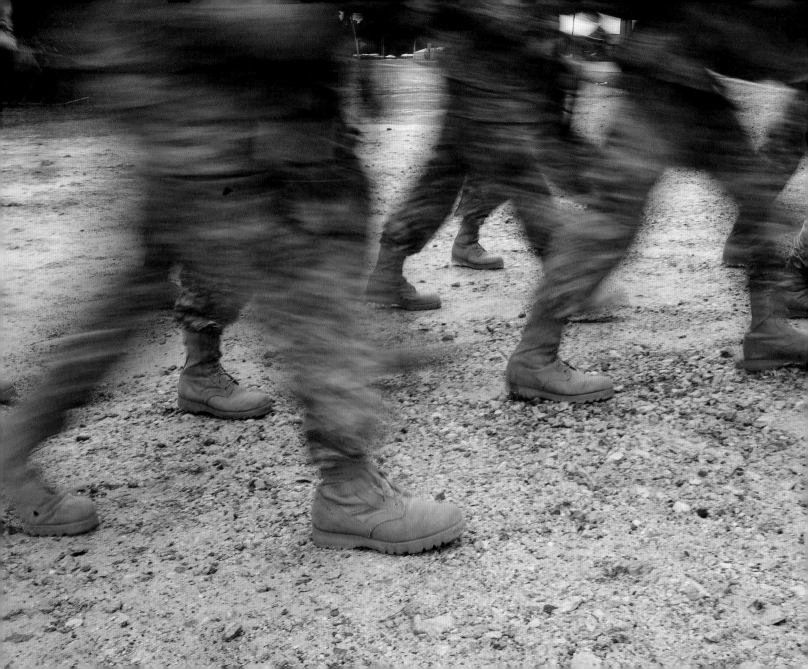

BIRTH OF A WARRIOR

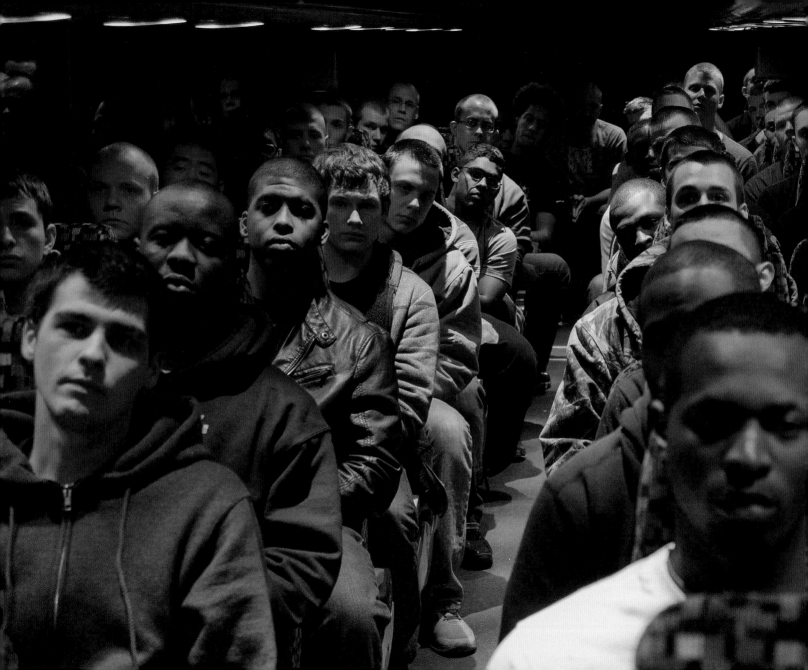

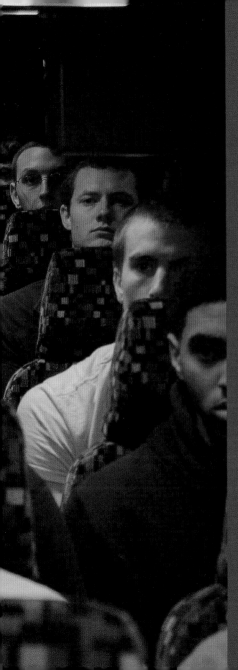

New Army recruits wait on a charter bus after arriving at Fort Benning and listen to a drill sergeant at 30th Adjutant General Reception Battalion (30th AG), the first stop upon arriving for basic training.

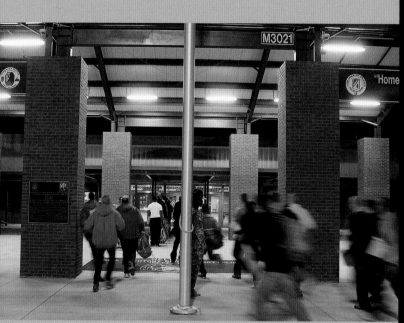

Recruits run into the main 30th AG
building to begin processing.

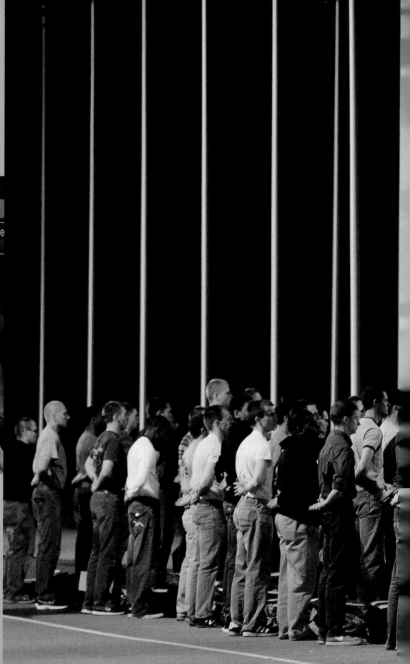

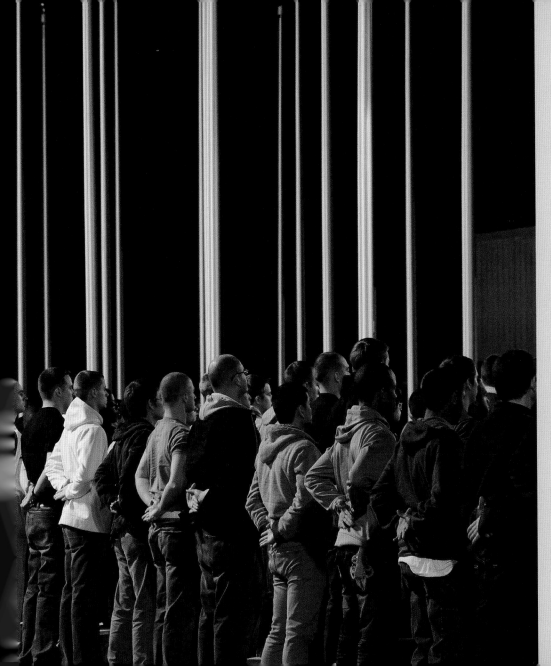

Recruits line up in civilian
clothes after arriving at 30th AG
in the early morning hours.

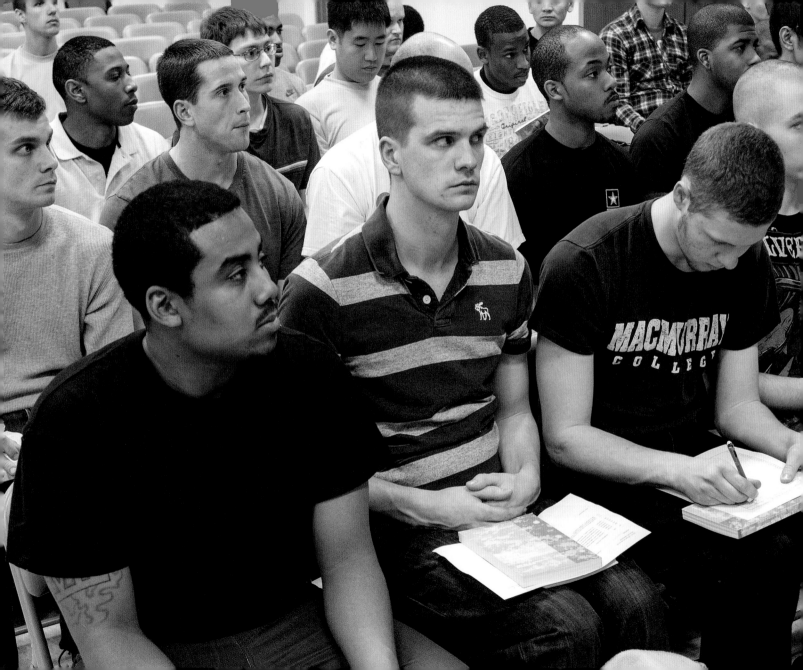

After arrival, recruits are taken through a thirty-six-hour whirlwind of processing that includes paperwork, instructional classes, uniform outfitting, and medical screenings.

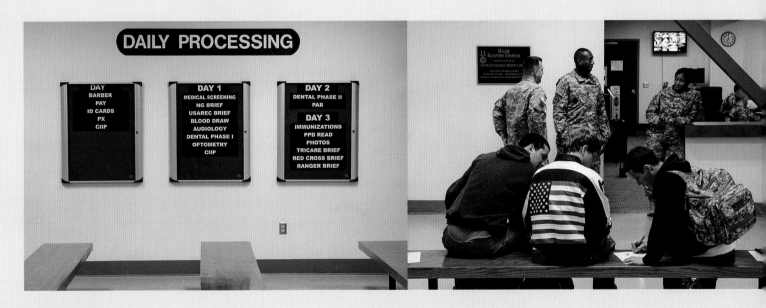

Boards displaying the first three days of processing hang on the wall at 30th AG.

New arrivals begin filling out paperwork minutes after arriving at Fort Benning for basic training.

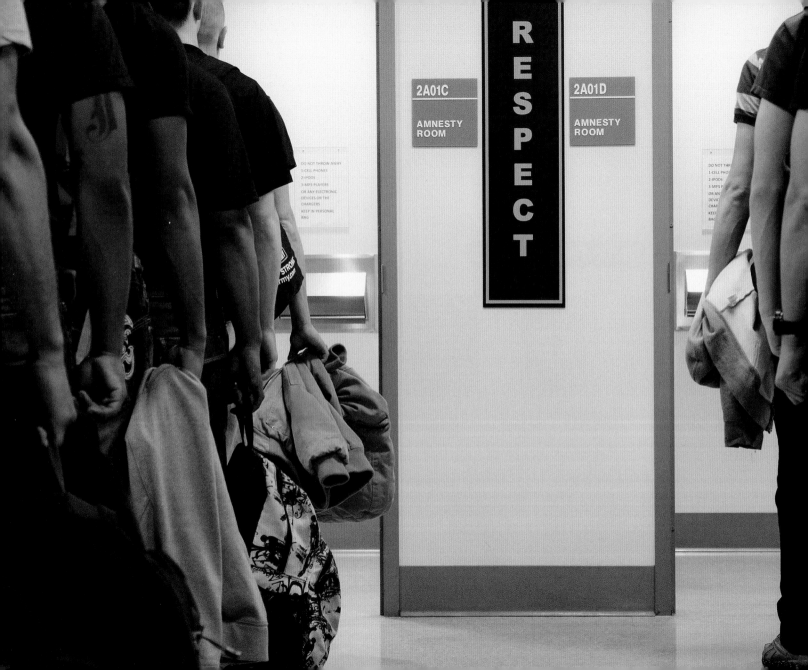

Recruits each get one opportunity to surrender without any repercussions any items that are prohibited during basic training in what is called the amnesty room.

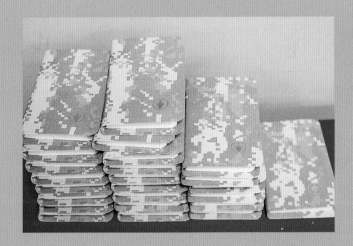

Camouflage New Testaments sit on a table.

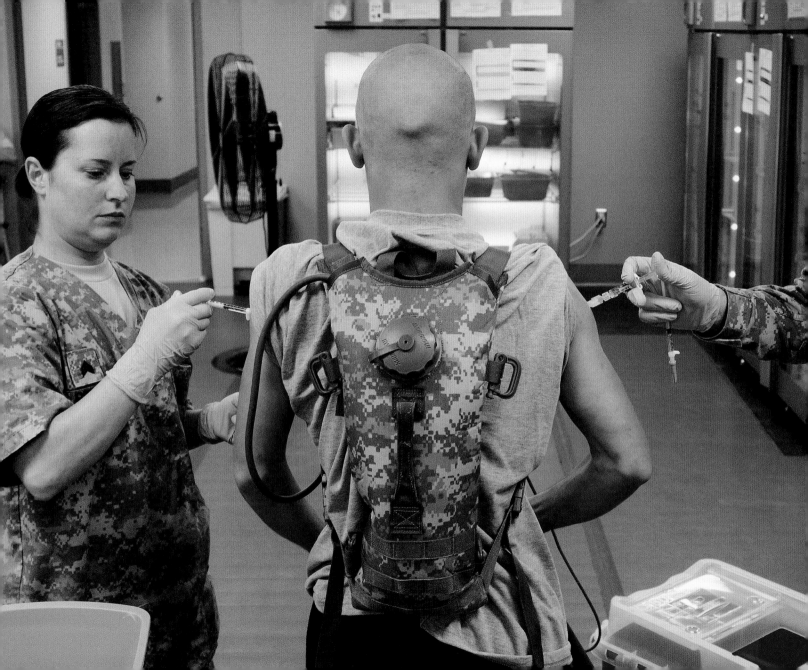

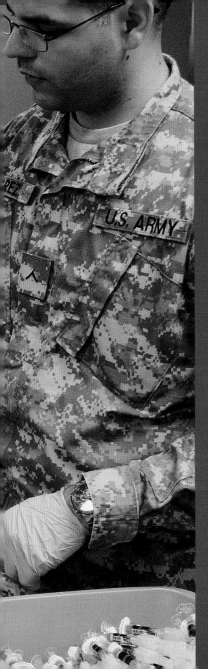

A recruit is given multiple injections during a medical screening during processing.

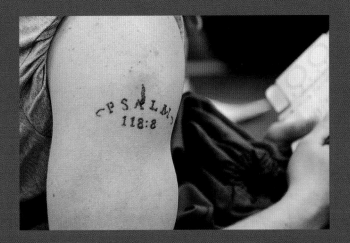

Blood drips from the arm of a recruit after he receives shots during the medical portion of processing.

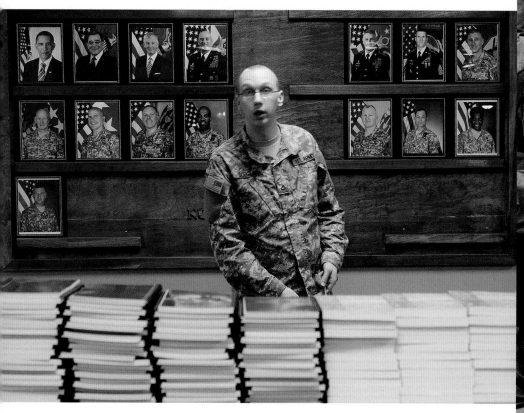

The chain of command is displayed on the
wall behind a recruit who is organizing
informational booklets.

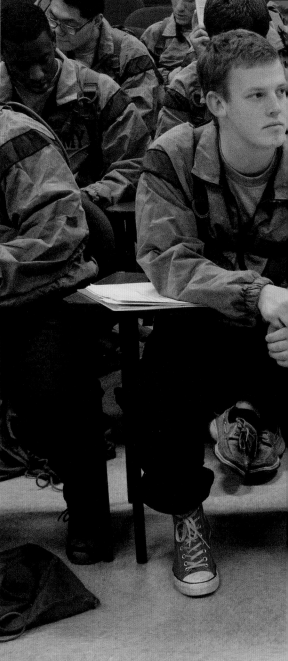

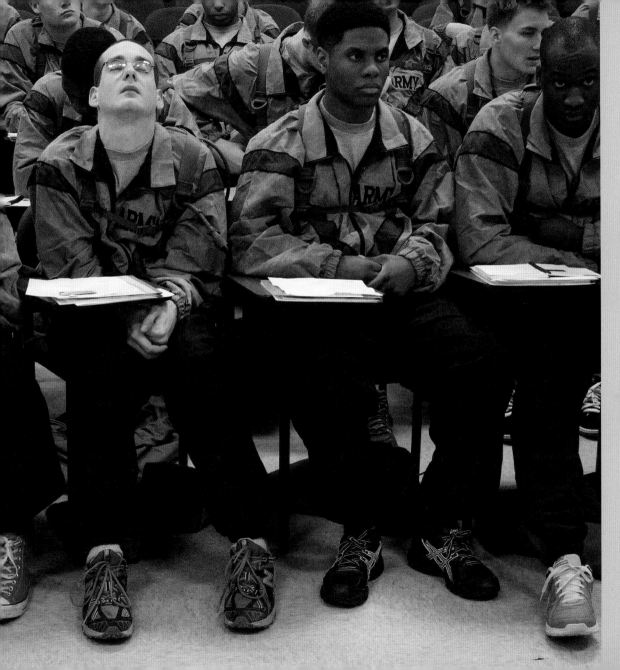

Long bus rides from around the country combined with the barrage of information and lack of sleep causes many recruits to fall asleep, some even while standing.

Recruits are allowed one call home once they arrive at Fort Benning and another two or three calls during the ten weeks of basic training.

DO NOT TOUCH THE WALL OR LEAN ON THE PHONE

A pile of clipboards with notes from previous recruits sits in a bin at 30th AG.

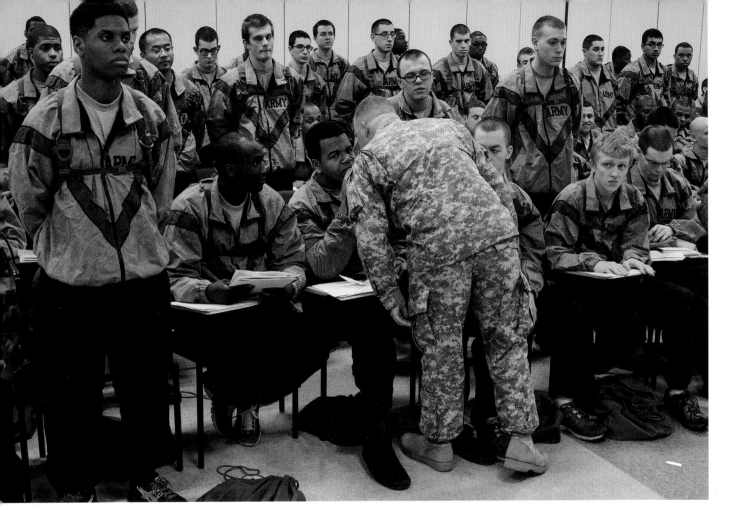

A recruit is given a stern warning from a drill sergeant after displaying a negative attitude. Other recruits are forced to stand so they will not fall asleep.

One by one,
recruits' heads are
shaved clean.

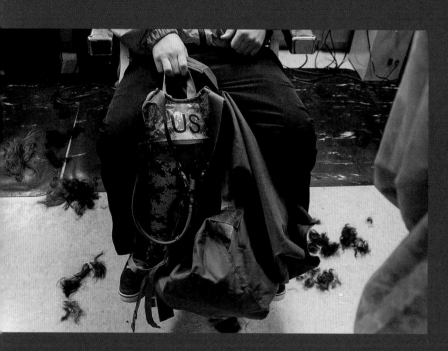

Hair is removed
from the heads of
all recruits.

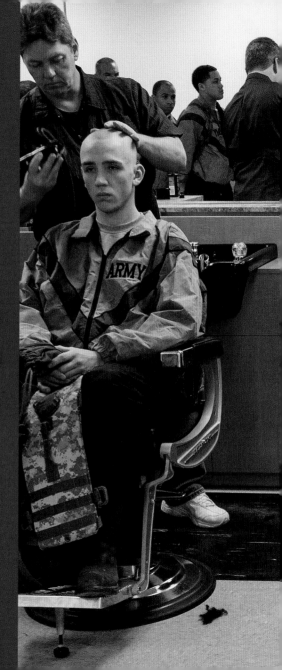

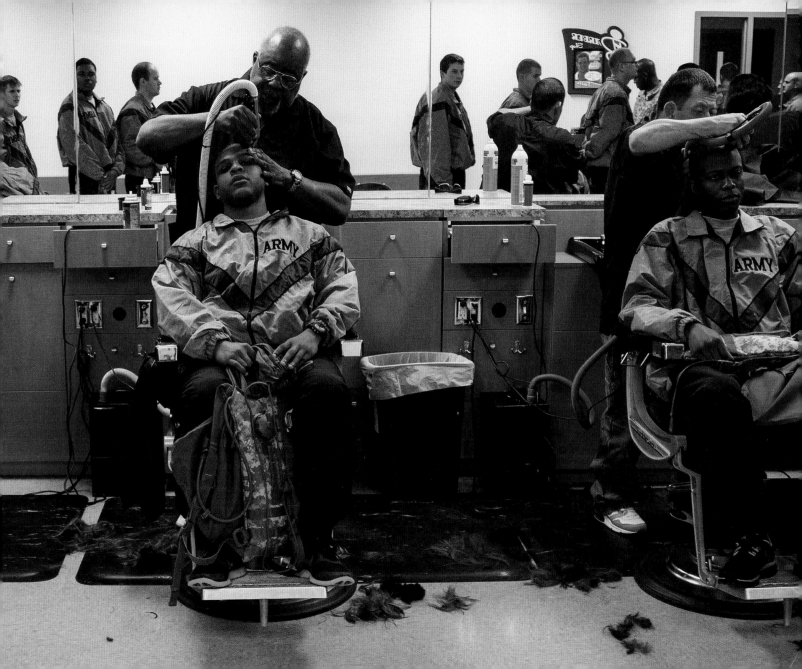

Recruits walk quickly between buildings throughout the night during processing.

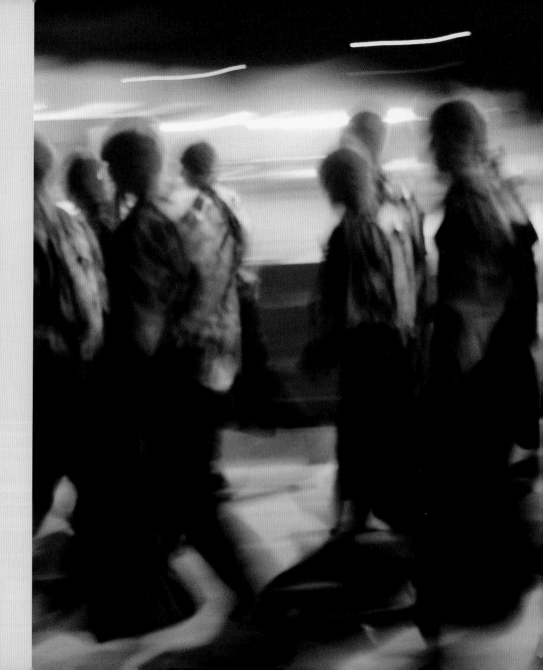

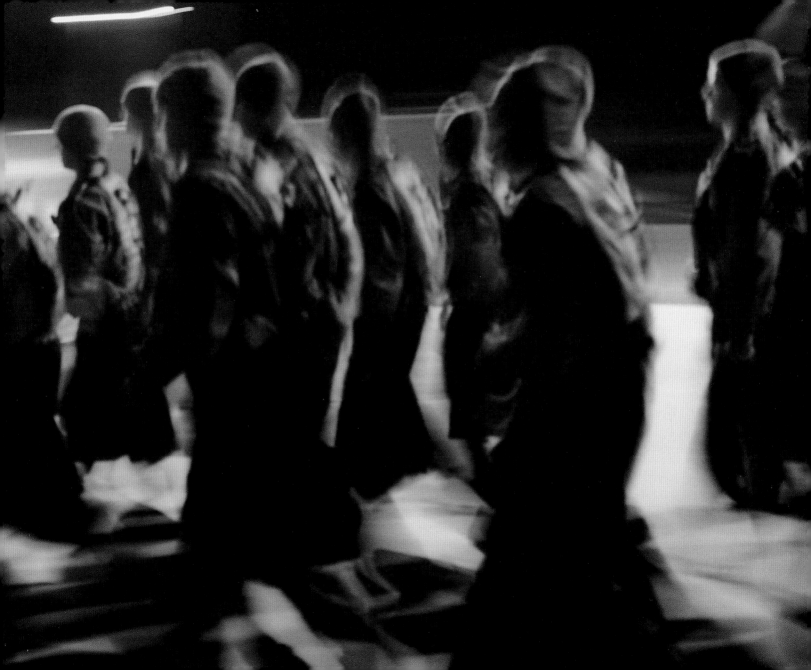

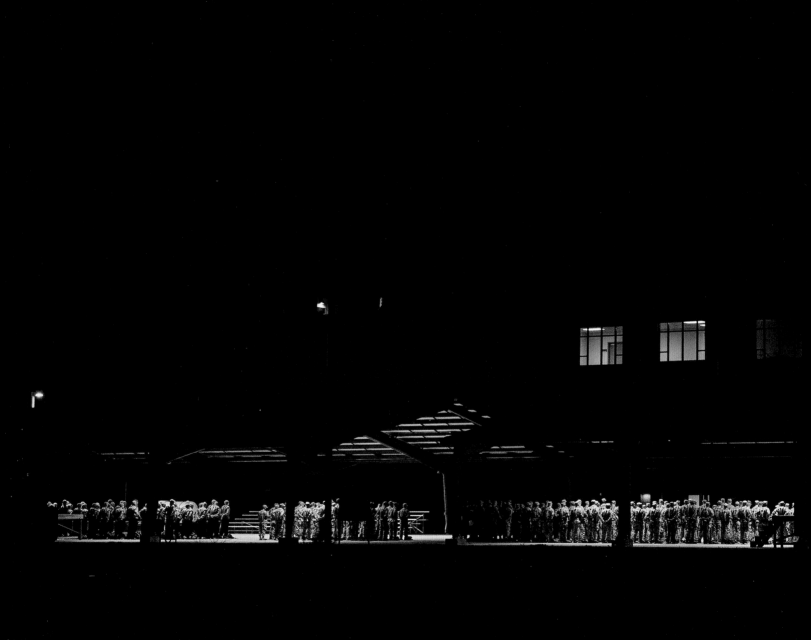

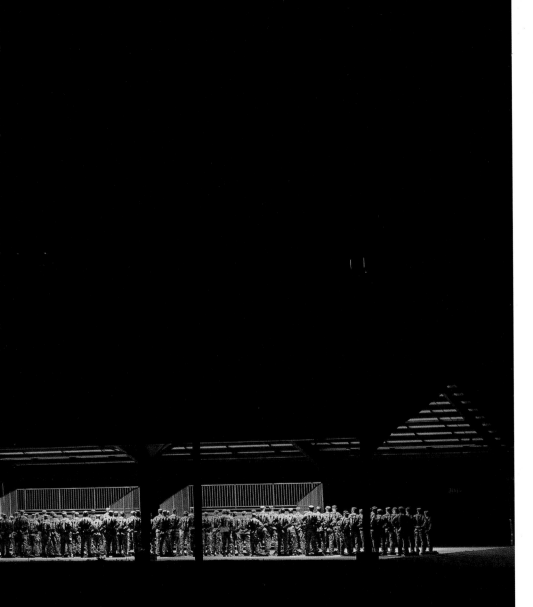

Recruits line up in the early morning hours in formation on the concrete pad outside the barracks at 30th AG.

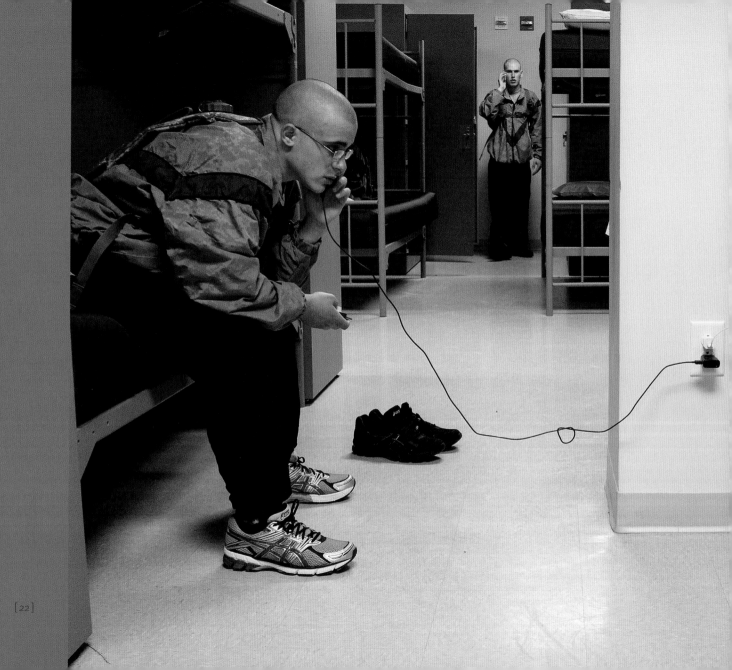

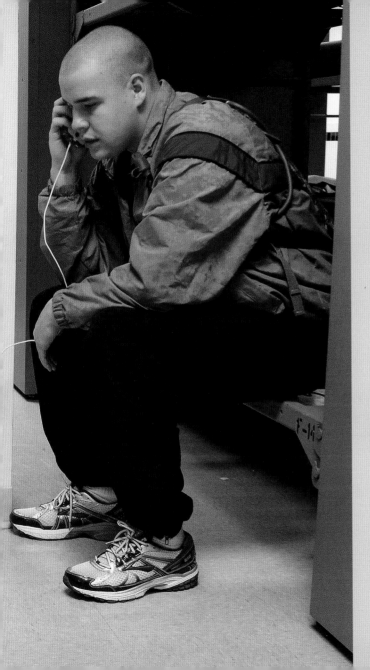

Recruits make their first call home to families from personal mobile phones but then are required to return the phones to the drill sergeant.

Stacks of army issue clothing and
uniforms line the shelves.

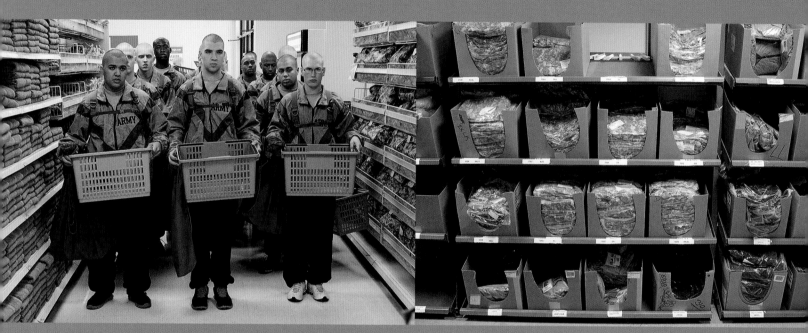

Recruits line up in the Post Exchange
(PX) to buy the essential items they need
to begin basic training.

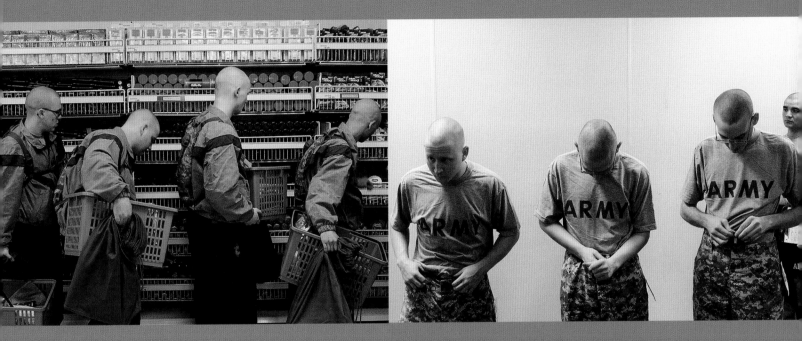

Recruits learn how the standard issue army combat uniform (ACU) should fit.

Recruits fill their baskets with essentials from the PX.

A recruit is given a dental exam
during processing.

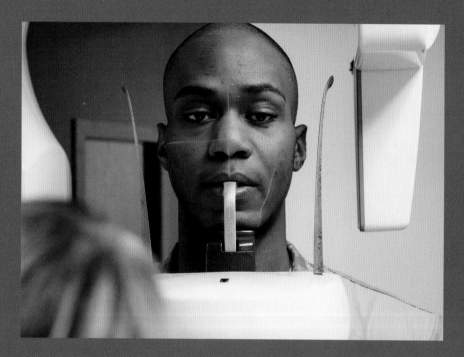

A recruit is given a
vision exam.

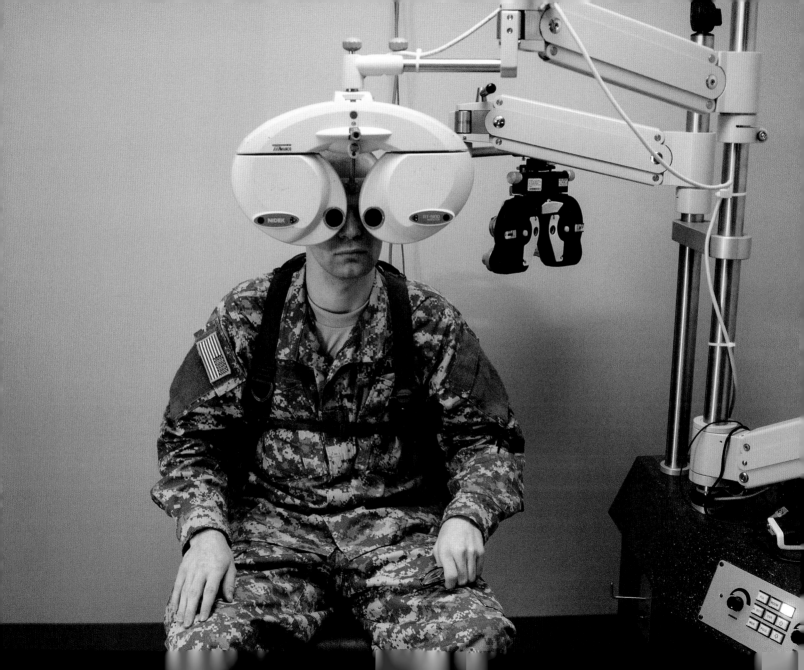

A 30th AG drill sergeant walks through the barracks waking the recruits.

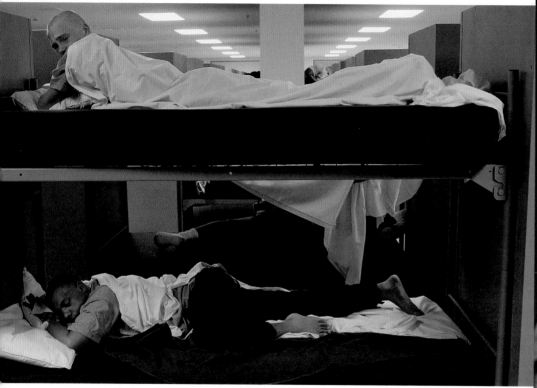

Recruits are awakened at 4:00 a.m. by a drill sergeant. They must be in formation outside at 4:30.

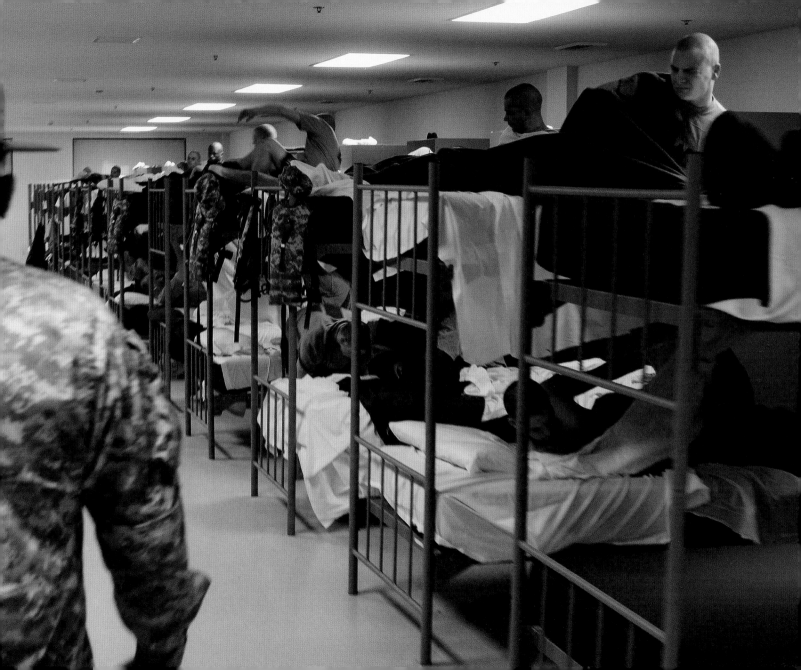

Sun shines on a recruit's freshly shaved
head as they line up in formation.

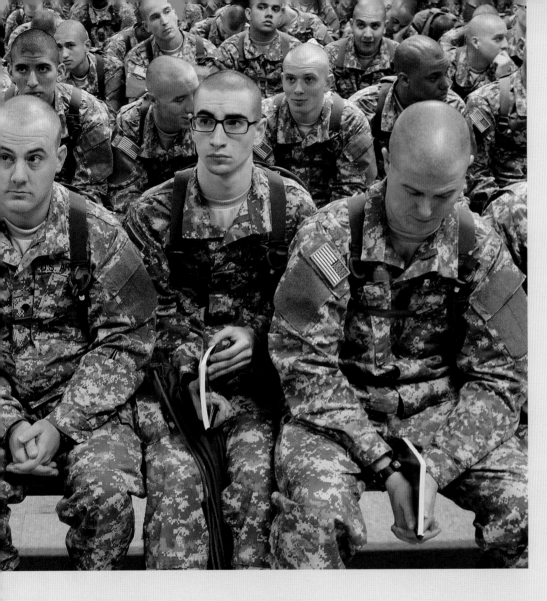

Recruits listen to orders from a drill sergeant at 30th AG during processing.

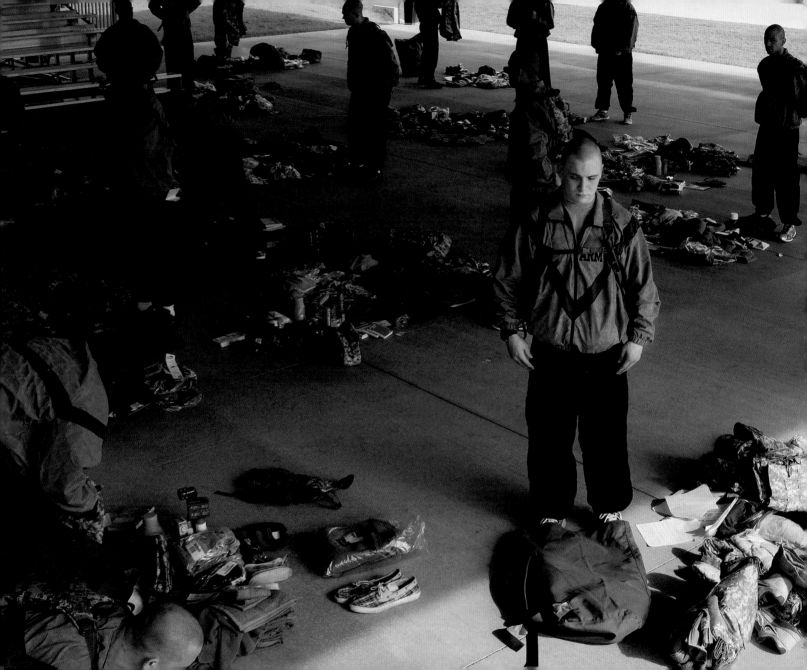

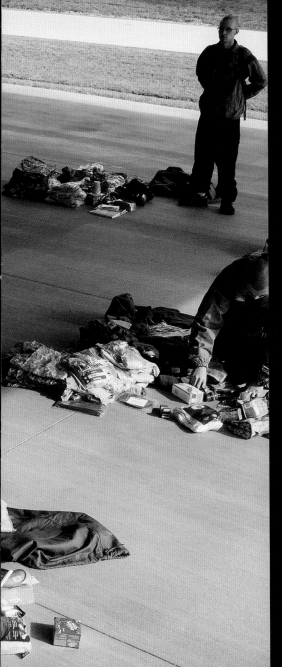

Recruits stand amid their personal items
and newly issued uniforms as a drill
sergeant helps them organize.

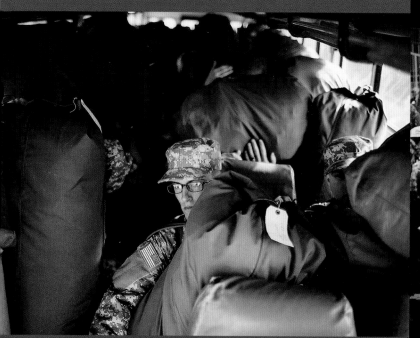

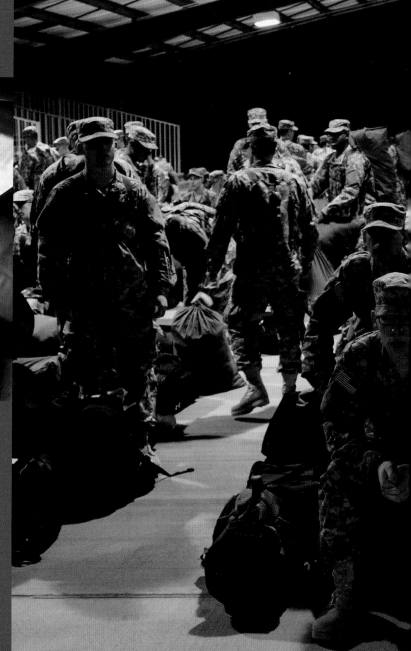

Recruits carry all their possessions and
pack onto the transport bus taking them
to Delta Company headquarters.

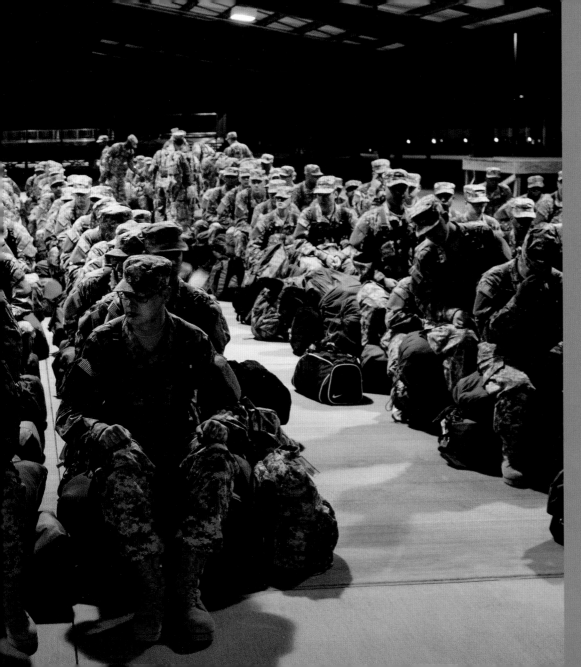

After seven days at 30th AG Reception Battalion, the 162 members of Delta Company 2/47 line up on "ship day" as they wait for transport to Delta Company headquarters, where they will spend the next nine weeks.

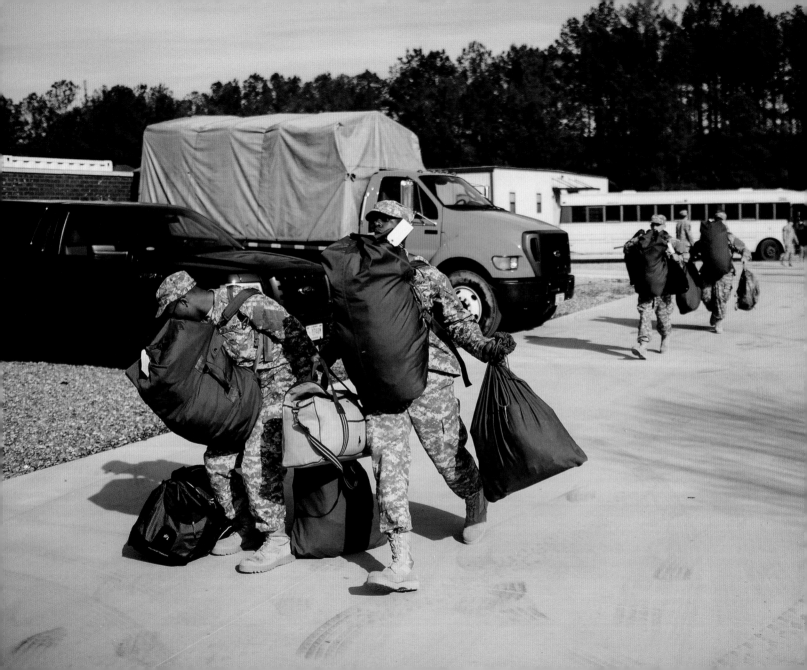

Recruits arrive at Delta Company and must run to the barracks with all their gear as drill sergeants motivate.

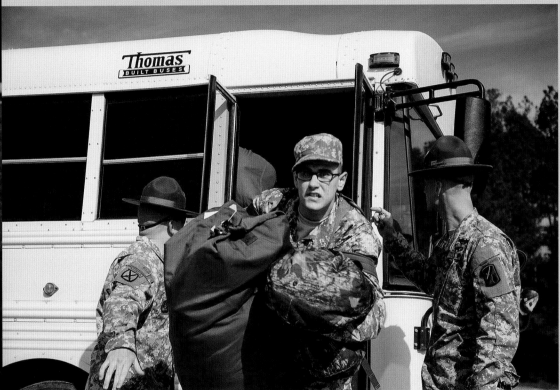

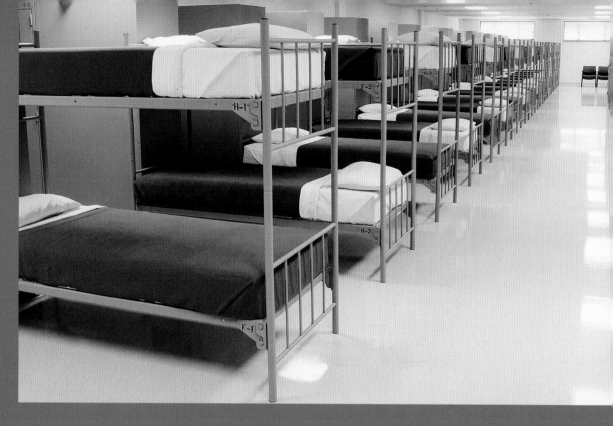

Platoon barracks await new recruits.

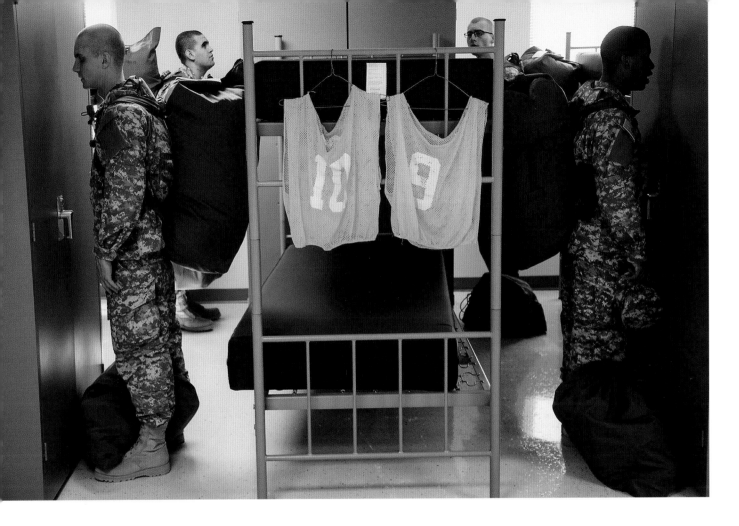

Recruits line up in the barracks of
Delta Company 2/47 upon receiving
their platoon assignments.

Recruits discuss their
new living arrangements.

Soldiers are allowed few
personal belongings, but
essential religious items
are an exception.

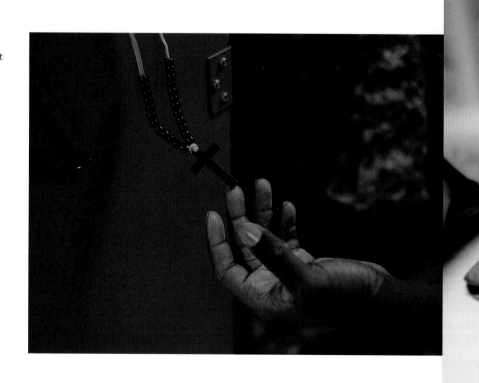

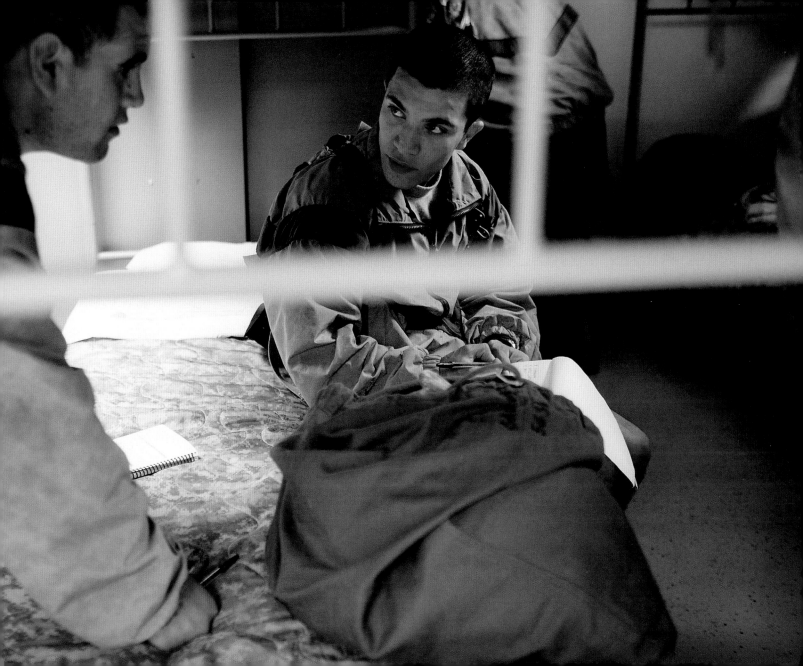

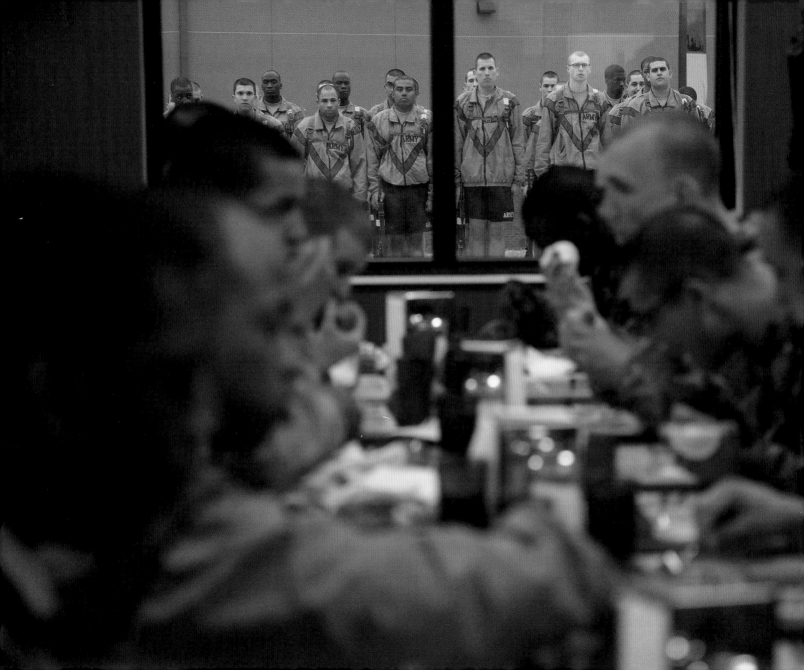

A platoon from Delta Company 2/47 is forced to wait outside in formation while others from the company finish eating.

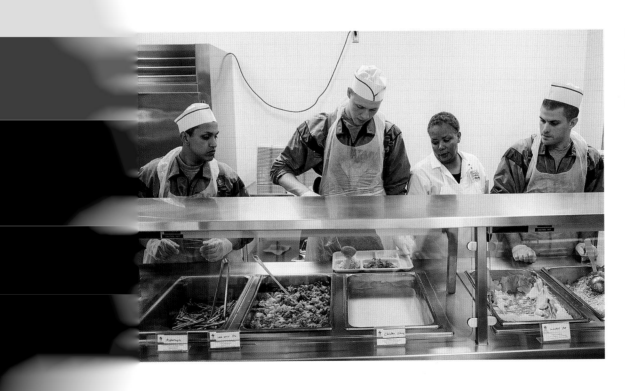

Recruits are given duties that rotate on a weekly basis and include serving chow.

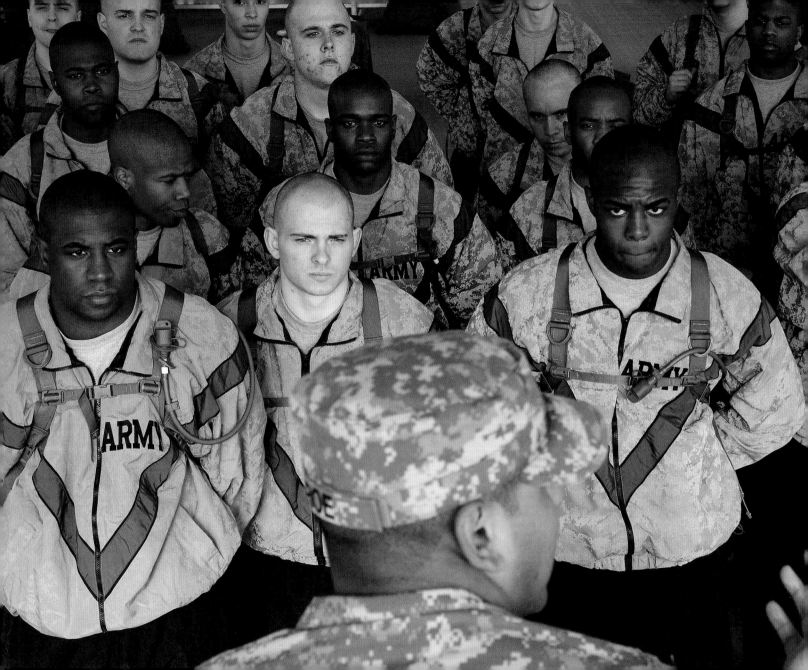

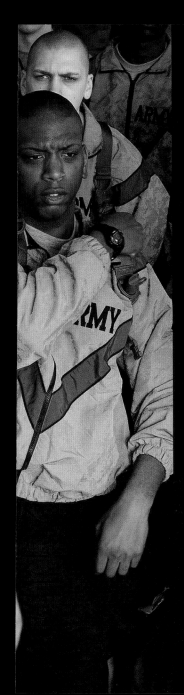

Recruits take orders from
a drill sergeant at Delta
Company headquarters.

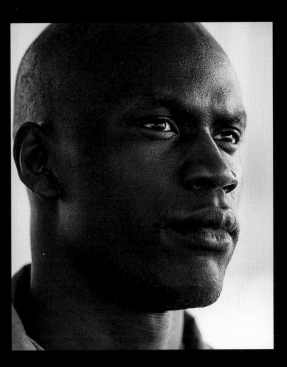

A recruit listens to a drill
sergeant's direction.

Recruits march
through Sand Hill, the
primary location of
basic training, at Fort
Benning.

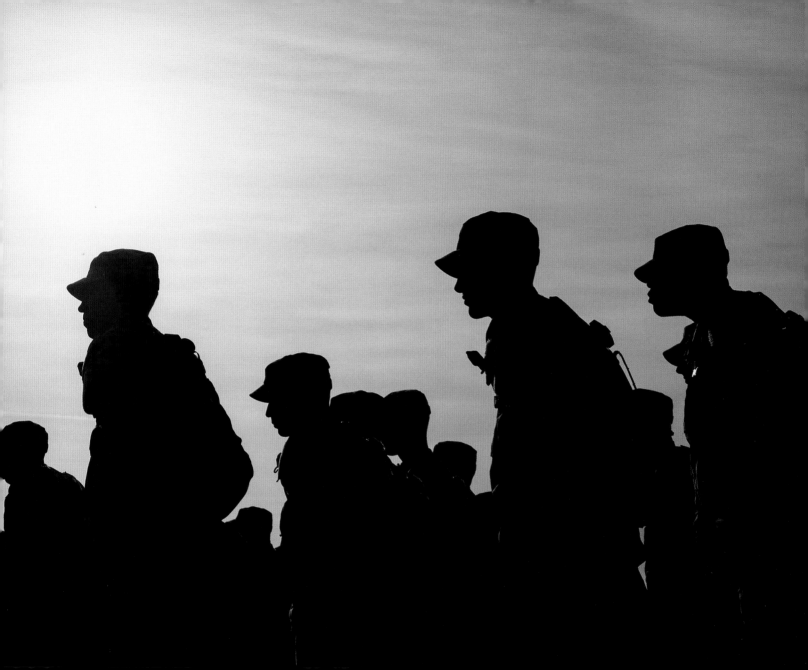

Recruits participate
in hand-to-hand
combat training.

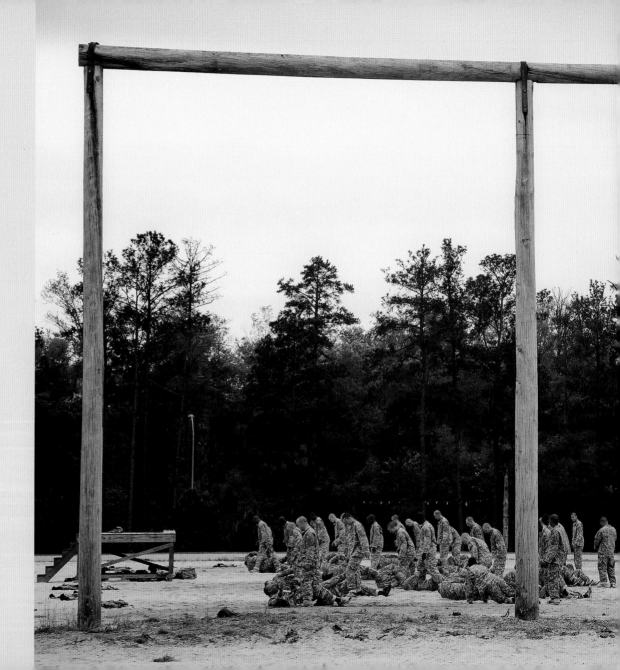

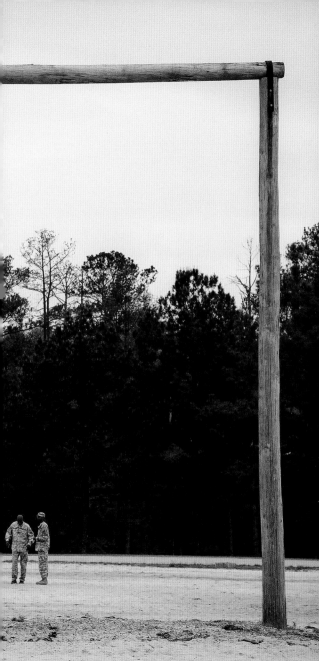

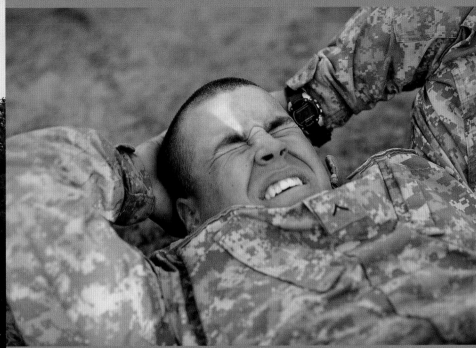

A recruit grimaces during daily morning
PT, or physical training.

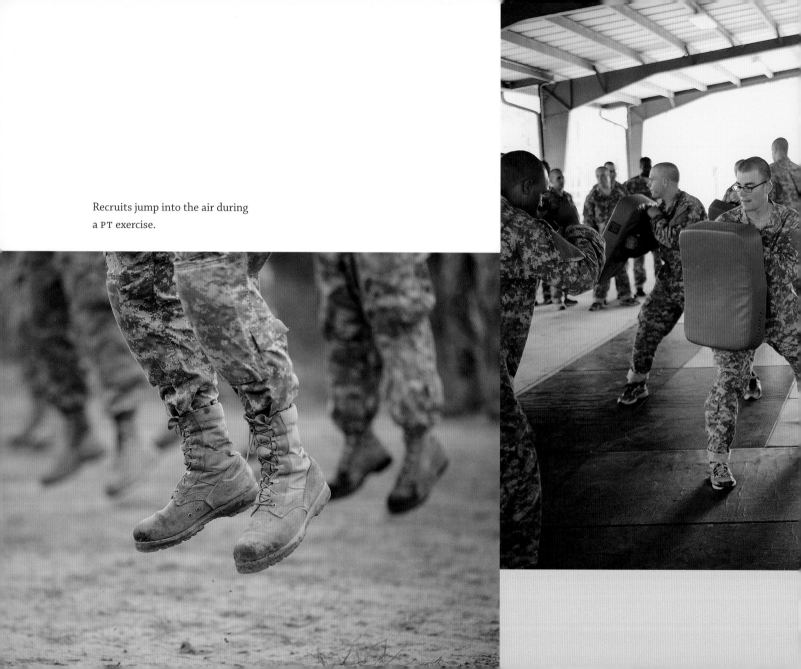

Recruits jump into the air during a PT exercise.

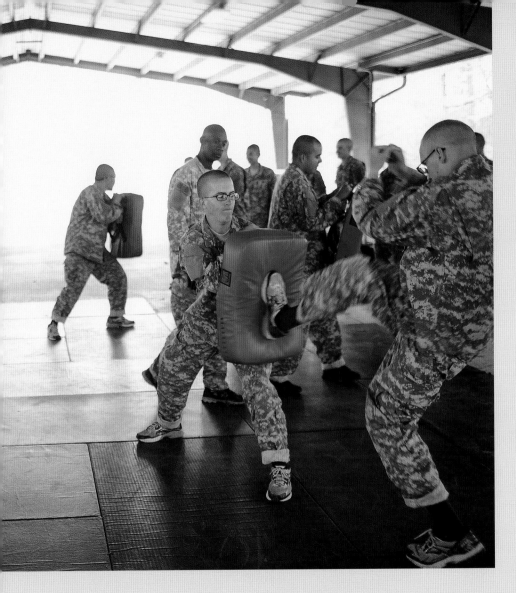

Hand-to-hand combat exercises are conducted with recruits.

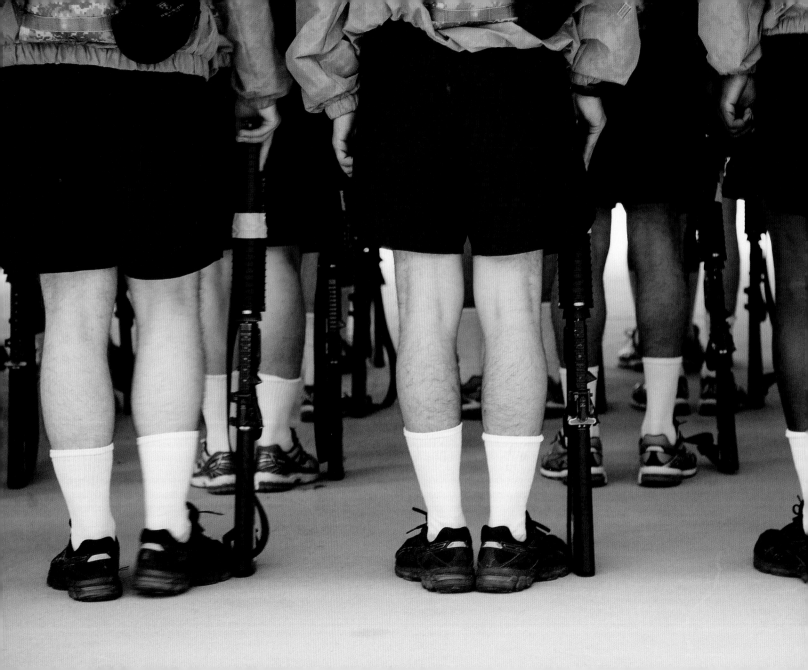

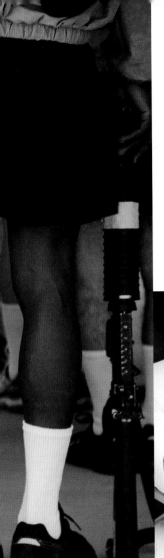

Recruits stand in formation wearing PT clothing.

Once issued their weapons, recruits are directed to never leave them out of sight.

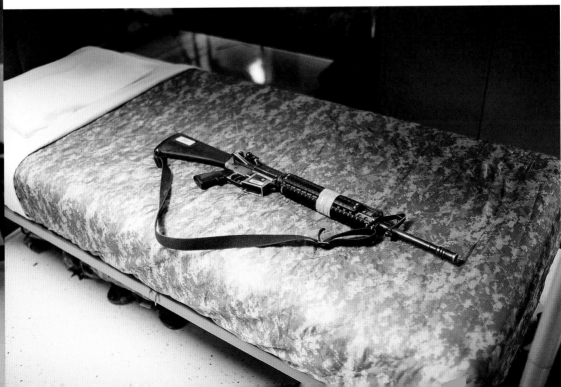

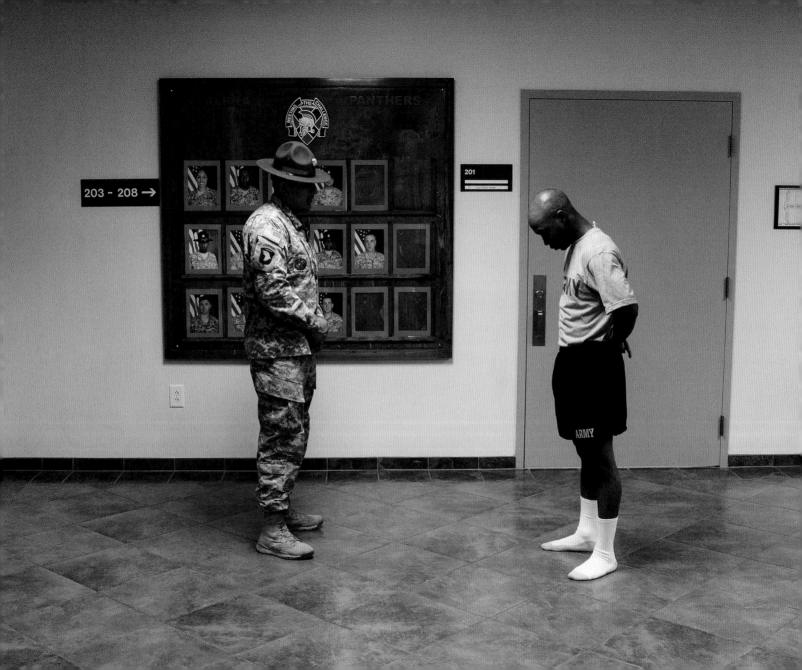

A drill sergeant has a one-on-one talk with a new recruit.

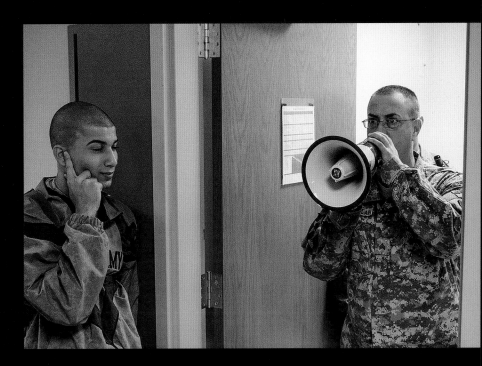

A drill sergeant uses a megaphone to give orders to recruits in the barracks.

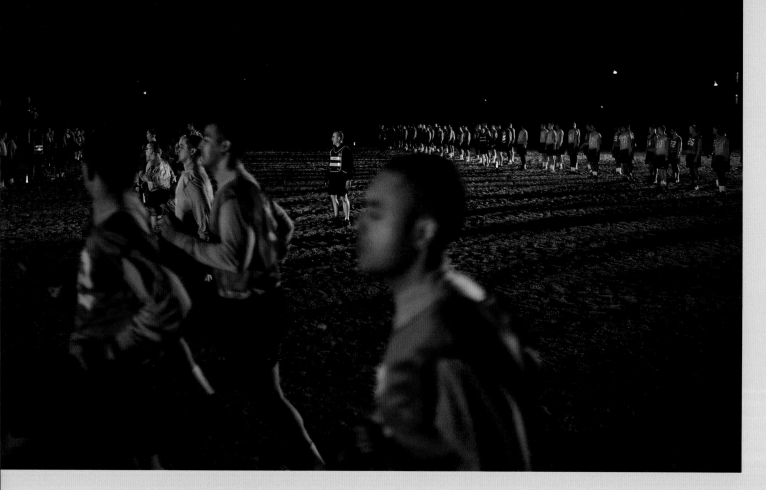

Recruits are required to do physical training every day
to meet certain requirements by the end of basic training
or they will not graduate.

PT is done every morning, usually well
before dawn.

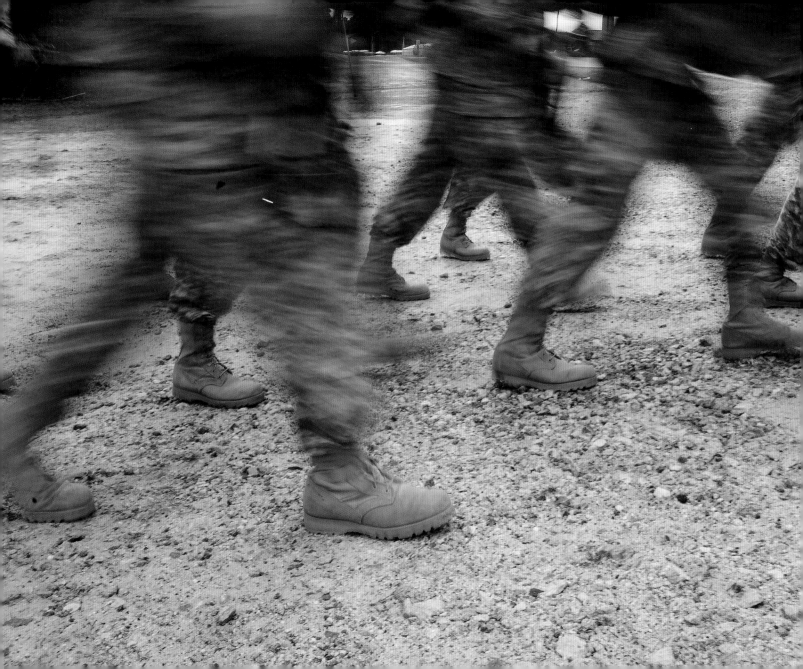

Recruits march in formation to a field training exercise.

In week three, recruits must pass their first big obstacle course, the forty-foot Eagle Tower at Sand Hill.

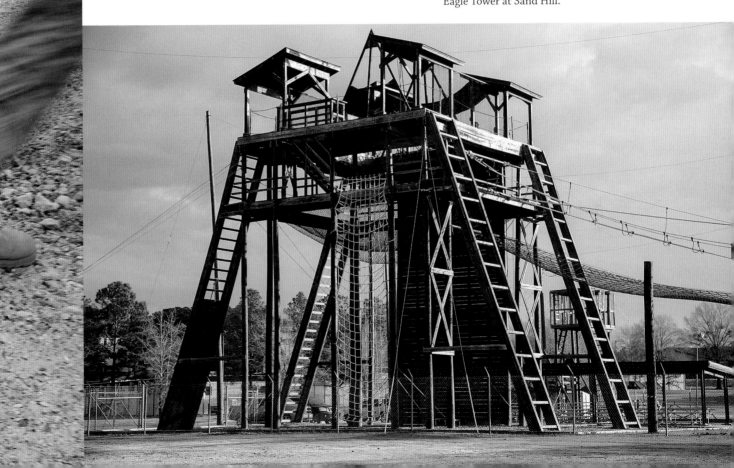

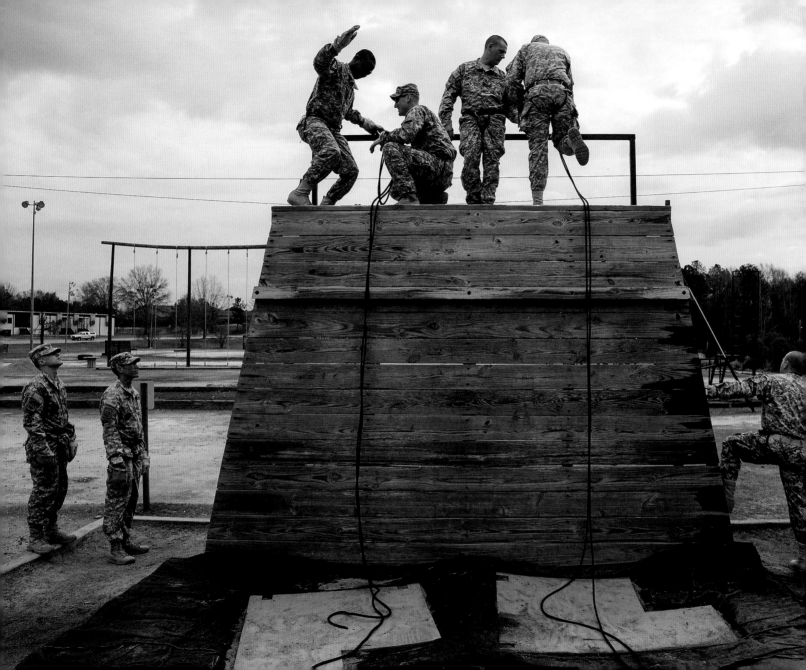

Drill sergeants participate in a rappelling certification class before beginning with recruits.

Recruits must successfully rappel down Eagle Tower.

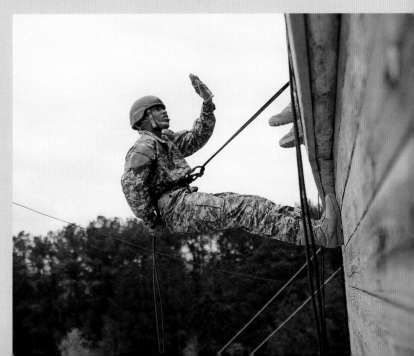

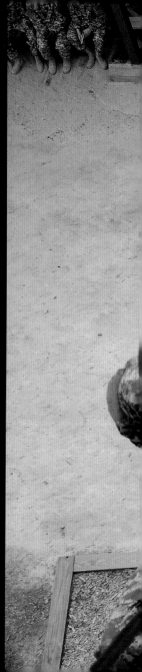

A drill sergeant looks up toward recruits as they rappel down the wall.

Recruits look up toward Eagle Tower, a rappelling wall and obstacle course that all recruits must complete in order to graduate.

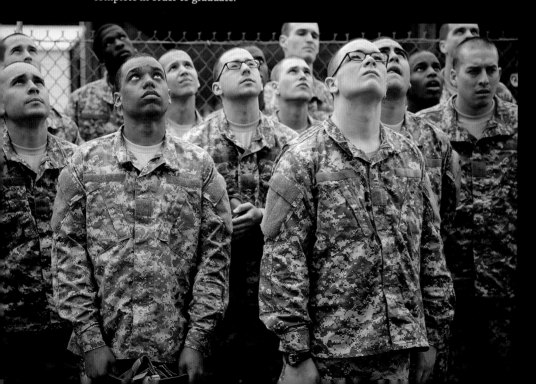

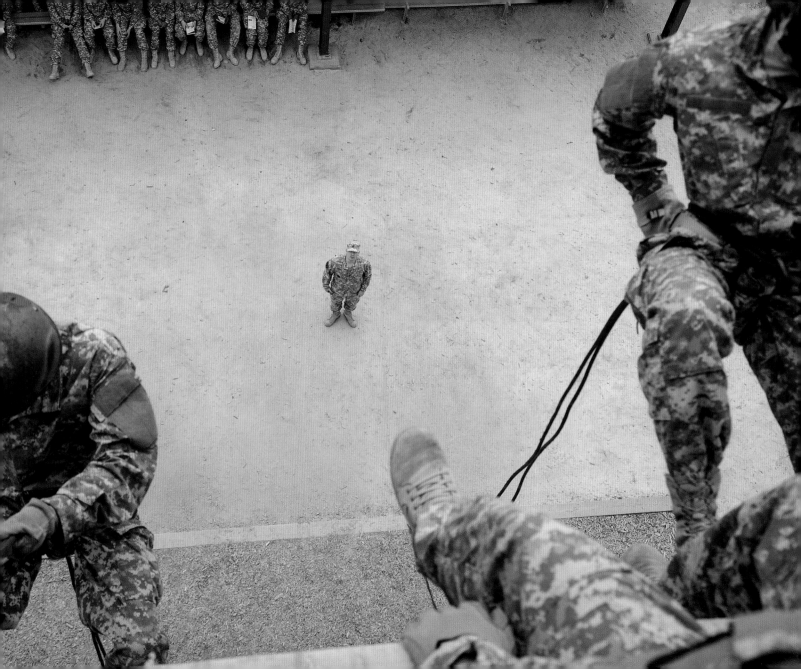

A drill sergeant encourages recruits as they take on the roped bridges of Eagle Tower.

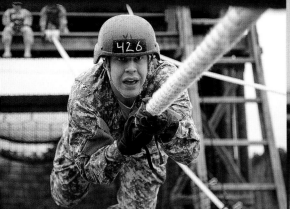

Recruits traverse part of the obstacle course on Eagle Tower.

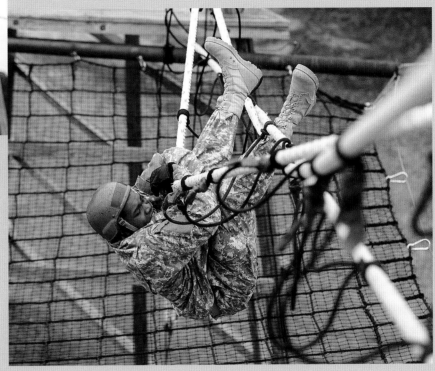

A recruit gets tangled in the rope bridge.

A cargo net is in place under the roped obstacles on Eagle Tower.

OPPOSITE PAGE
A recruit drops from the rope ladder to a pad on the ground below.

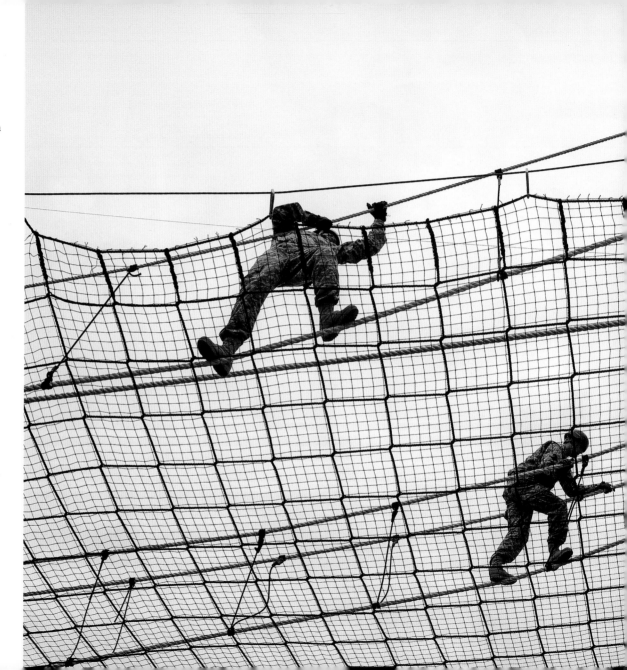

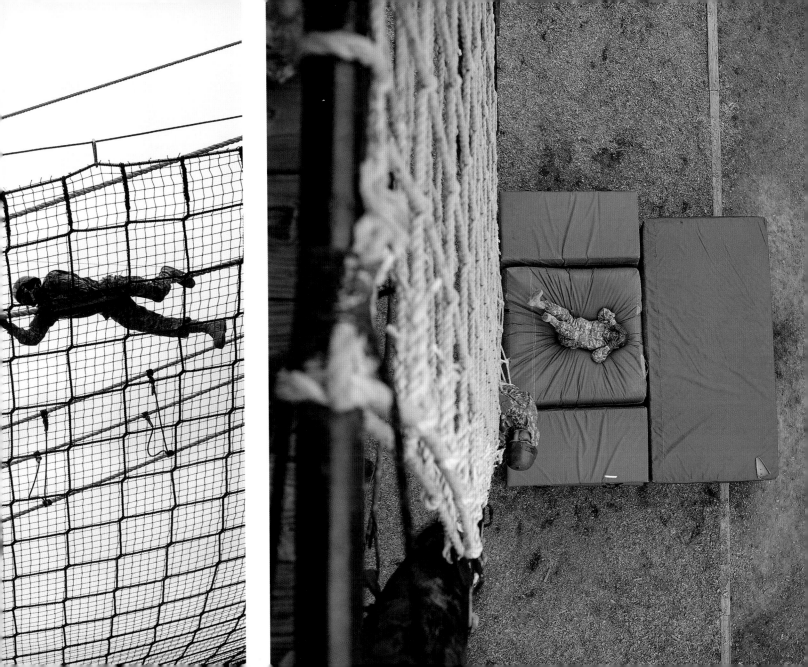

A drill sergeant orders pushups to "motivate" recruits.

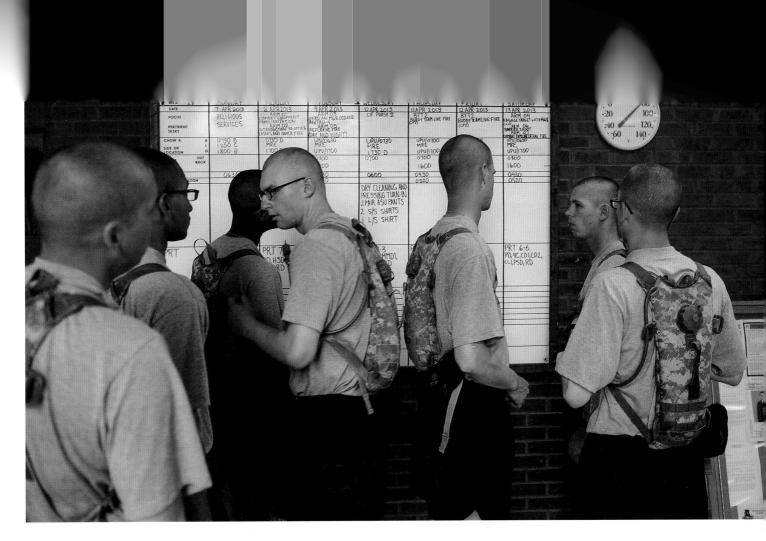

Recruits check the week's exercises on the
calendar posted outside the barracks.

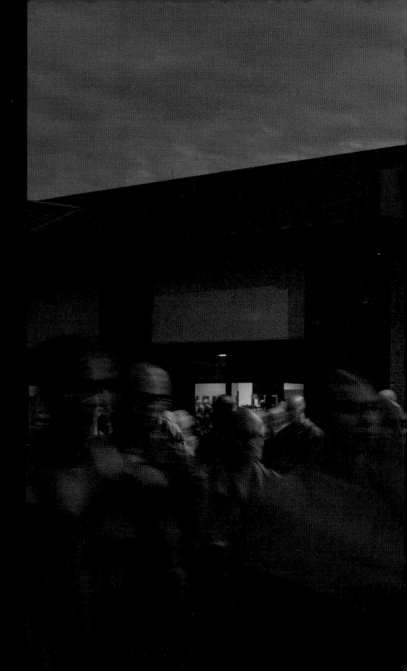

Recruits line up outside the
DFAC or dining facility
in the early morning hours
for breakfast.

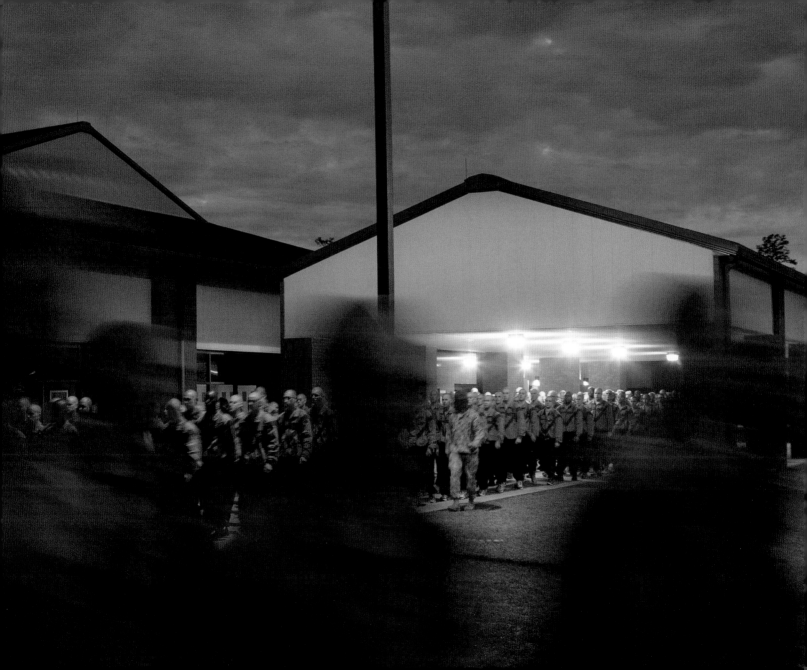

A group of recruits
assigned to manage
artillery at the range
discuss their orders.

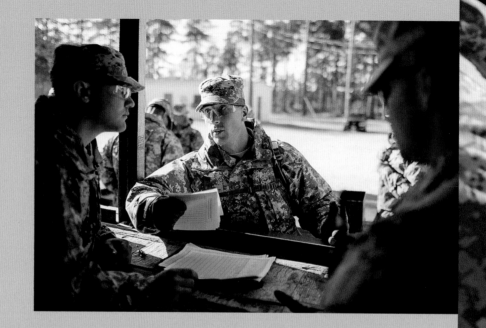

A group of recruits
loads clips for the
entire company during
marksmanship training.

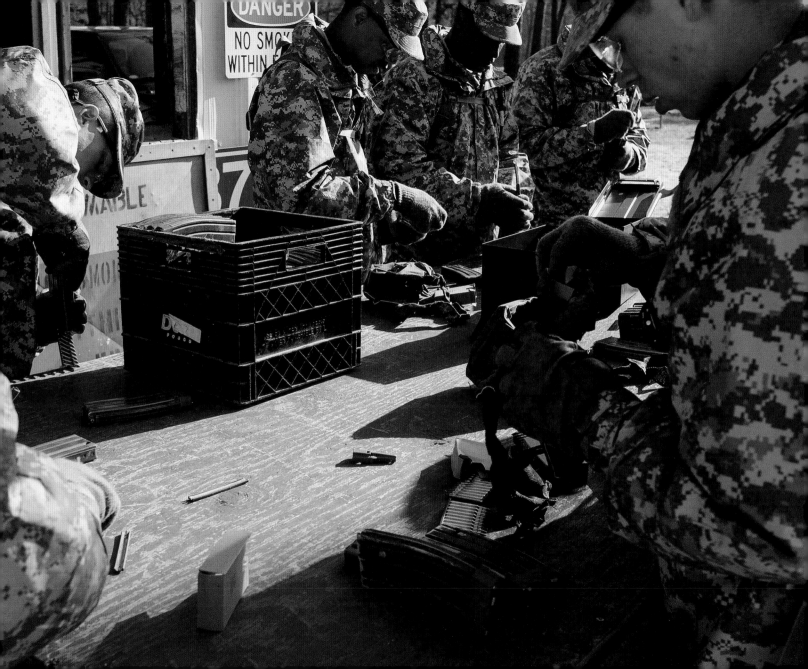

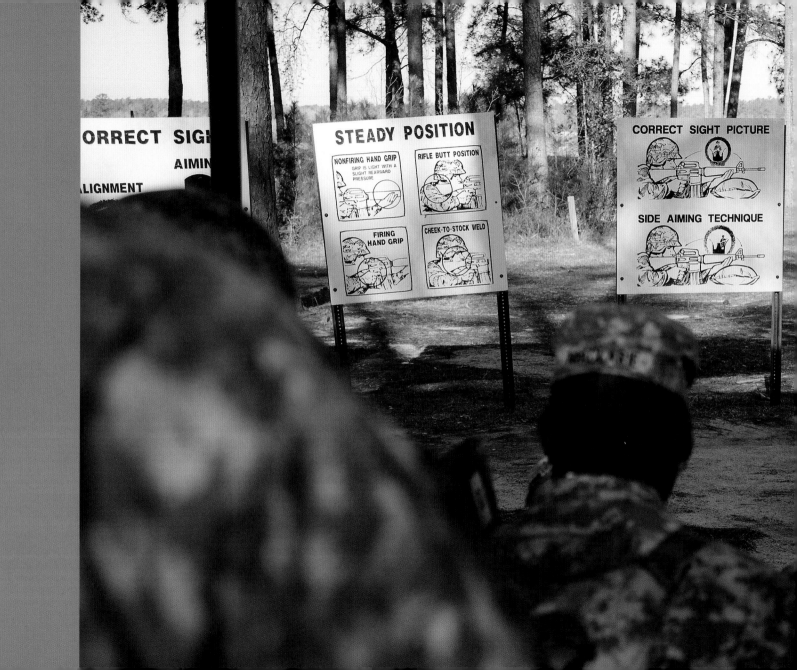

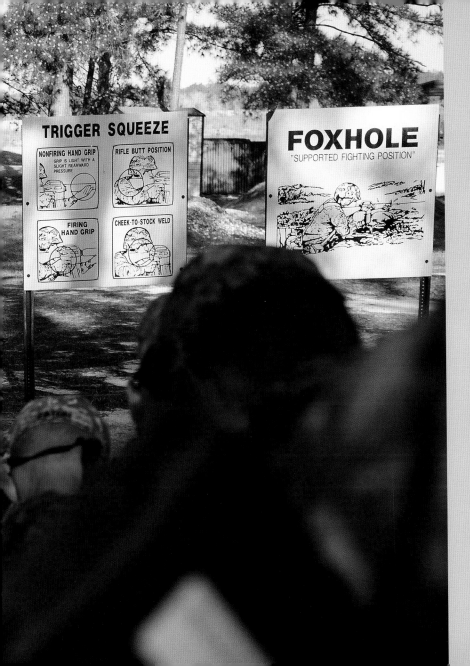

Instructional signs line the waiting area of the range.

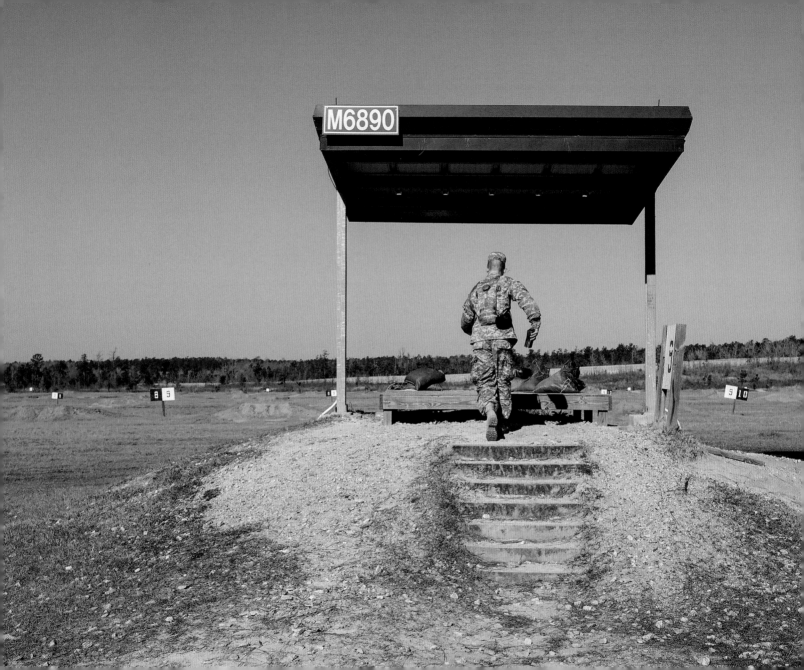

A recruit takes his
ammunition to the assigned
firing position.

Recruits receive orders from a
drill sergeant at the range.

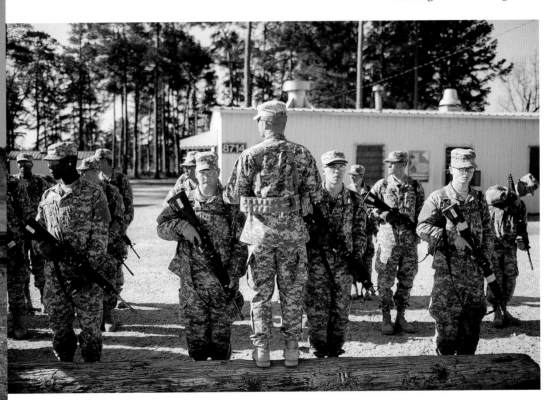

A drill sergeant monitors a recruit
as he fires on the range.

Recruits must meet accuracy standards at each of the different firing positions.

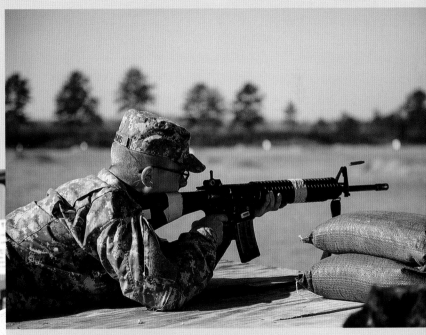

A recruit exhales in relief after receiving a passing score for basic rifle marksmanship.

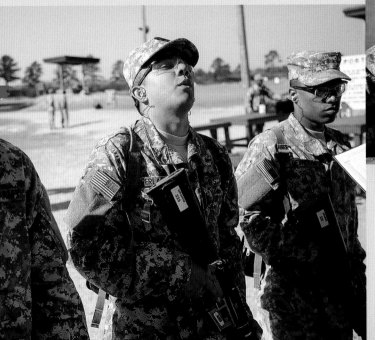

Rifles are pointed into a safety barrel and shown to be empty before the recruit and his weapon can leave the range.

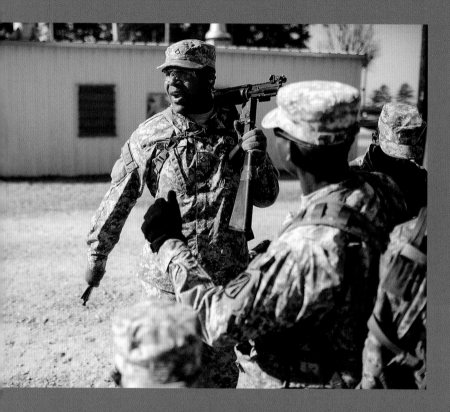

Drill sergeants check the weapons of recruits.

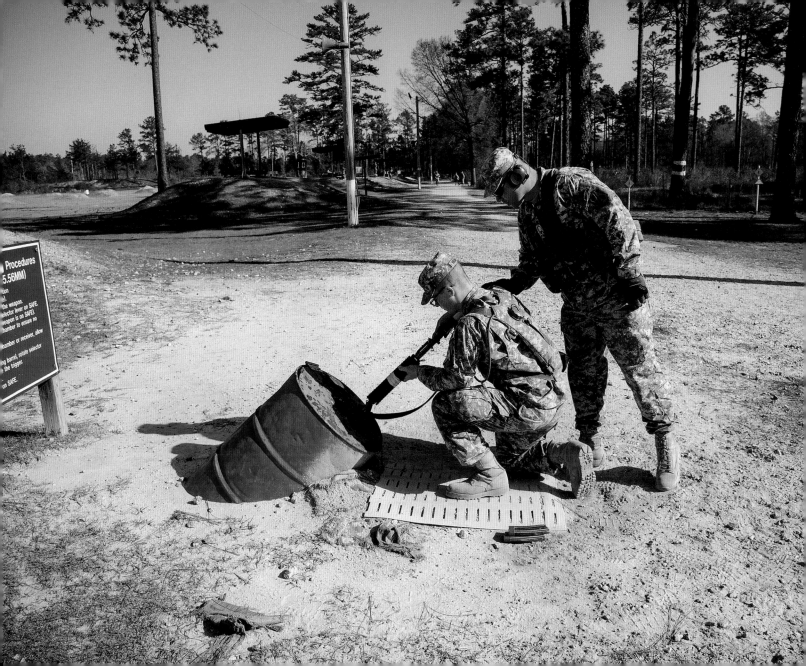

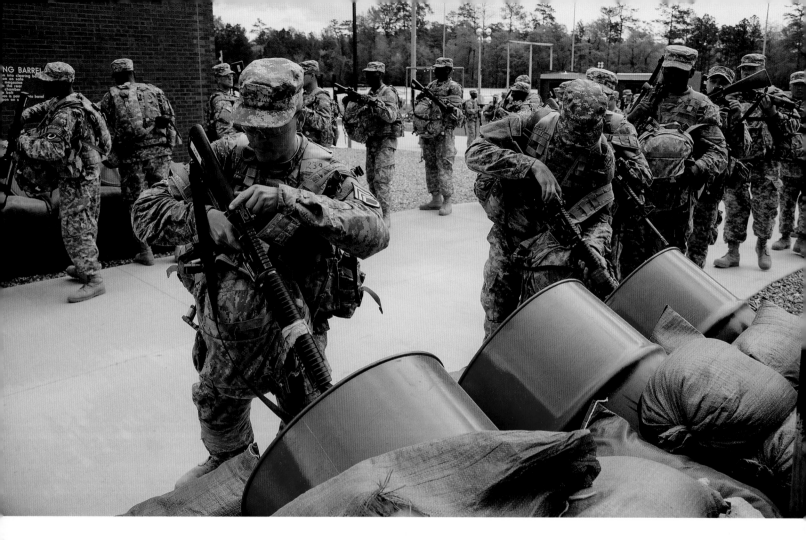

Recruits check rifles for ammunition
again outside Delta Company barracks.

A senior drill sergeant is brought lunch,
packed by his spouse in his childhood
lunchbox, during a field training exercise.

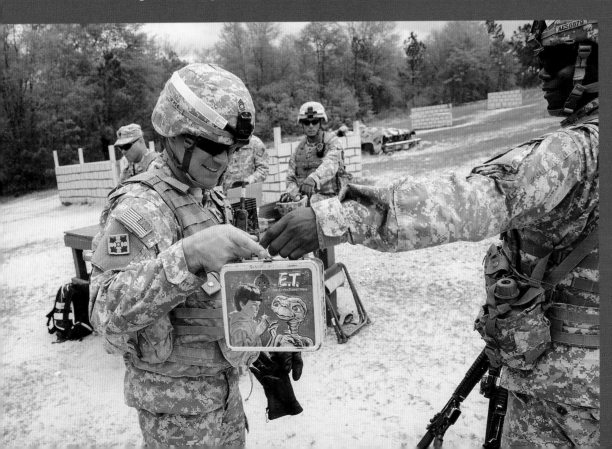

Recruits wait in a staging area during the buddy team live-fire exercise on one of the many ranges at Fort Benning.

A recruit's Bible sits on top of a Kevlar vest.

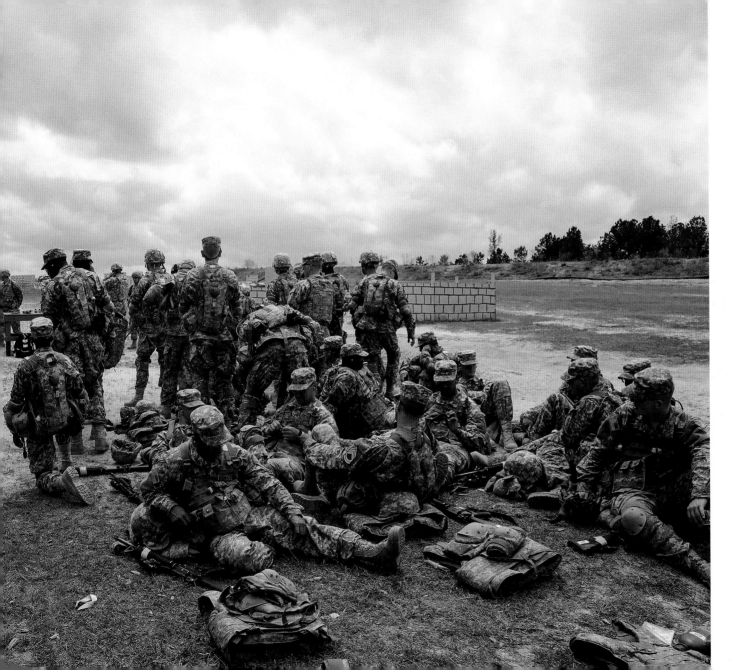

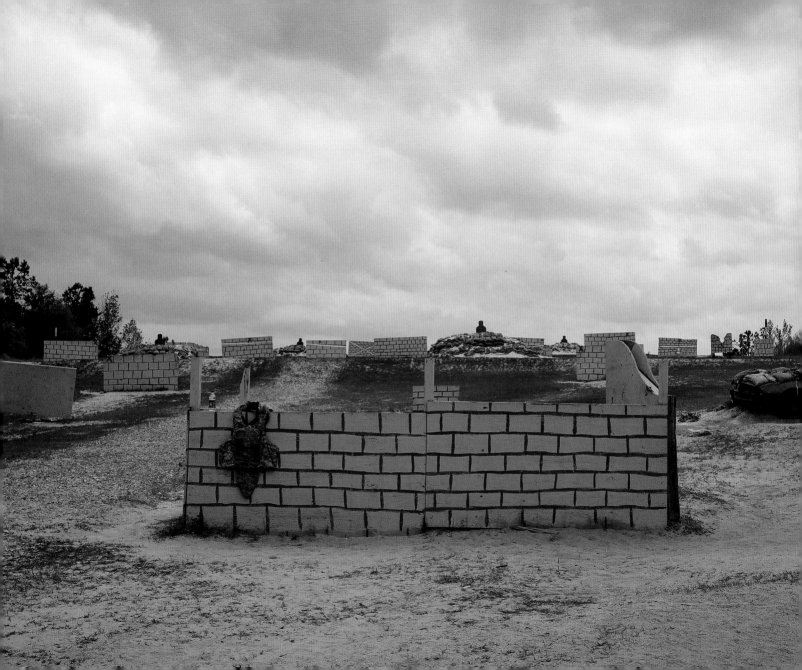

Recruits participate
in the buddy team
live-fire exercise.

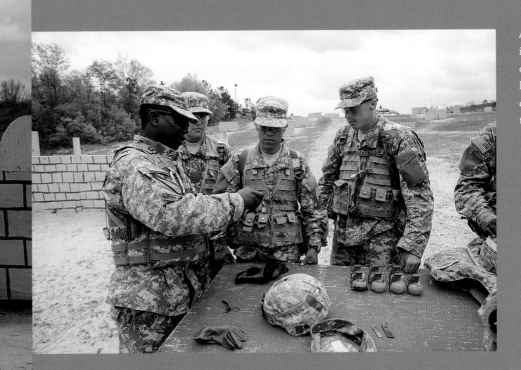

A drill sergeant
instructs recruits
on the use of live
hand grenades
during a field
training exercise.

Recruits are required to
submerge in a tank of ice
water after participating in
an exercise in full armor
in the middle of the day.

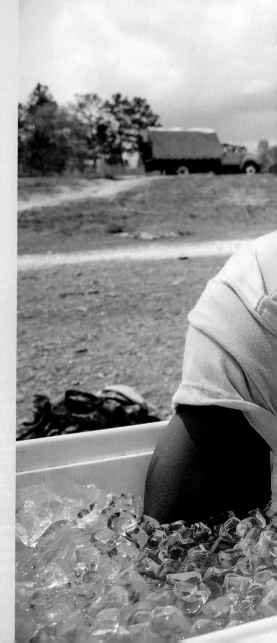

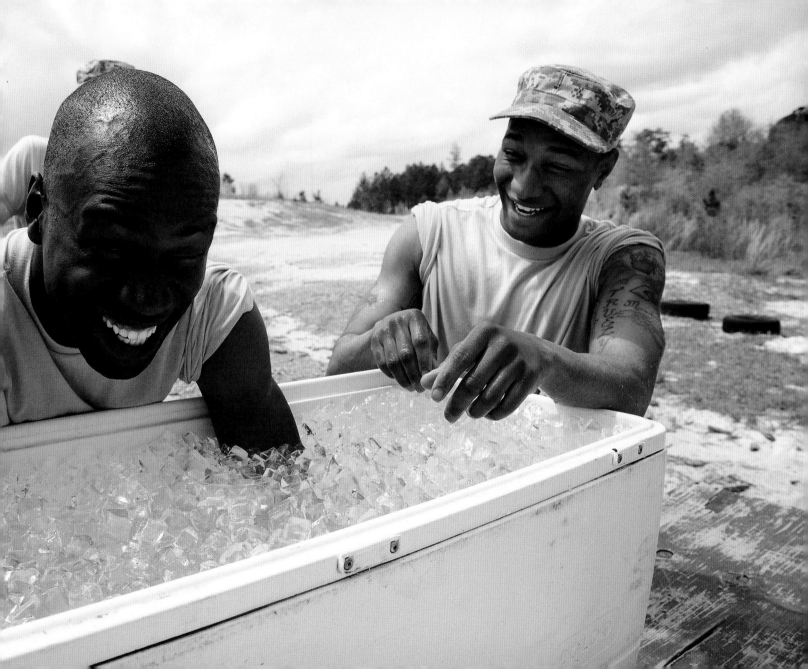

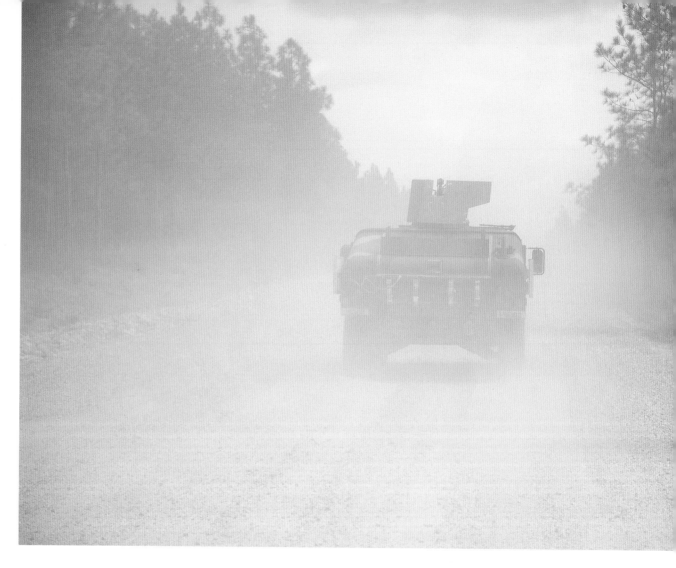

Recruits participate in a field training
exercise using Humvees.

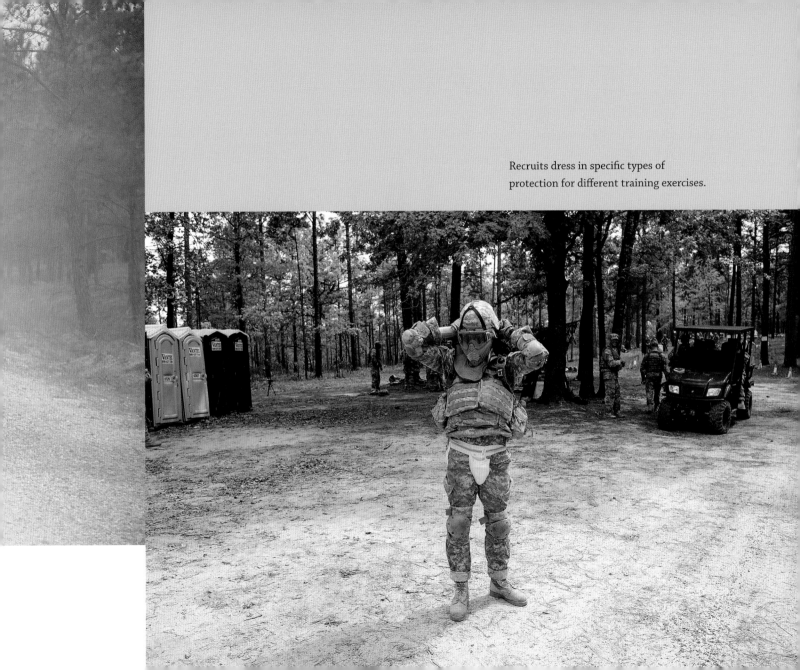

Recruits dress in specific types of
protection for different training exercises.

Recruits take part in a team exercise
at a mock town setting.

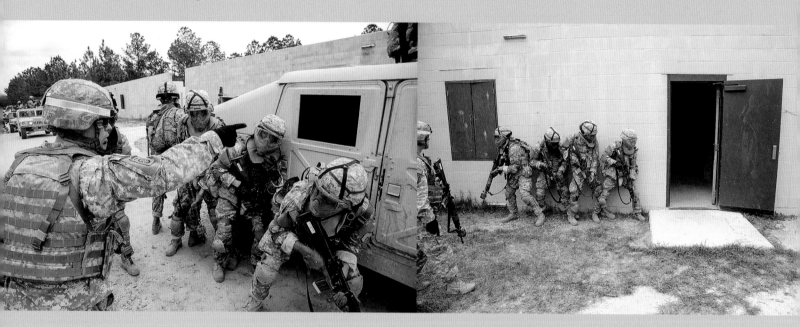

Drill sergeants designate a squad leader to
test each man's leadership potential.

A drill sergeant accompanies the
squad into the mock town.

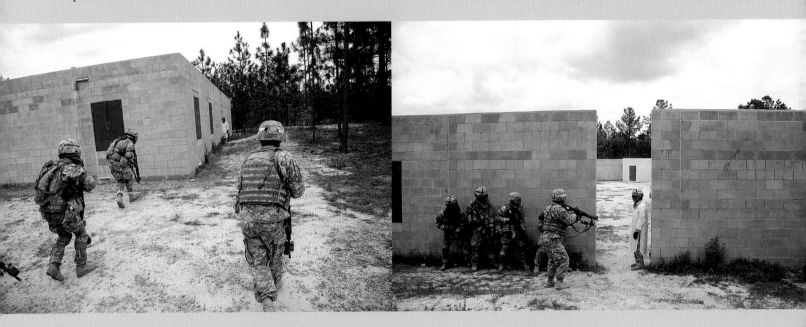

Recruits approach the mock town, in which
drill sergeants play the role of bad guys.

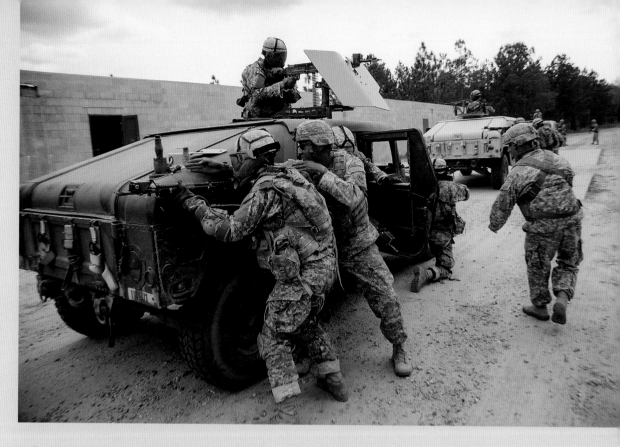

Drill sergeants direct recruits on
how to respond when being fired upon
in a convoy.

Recruits change equipment under a
shade tent during a multiday field training
exercise.

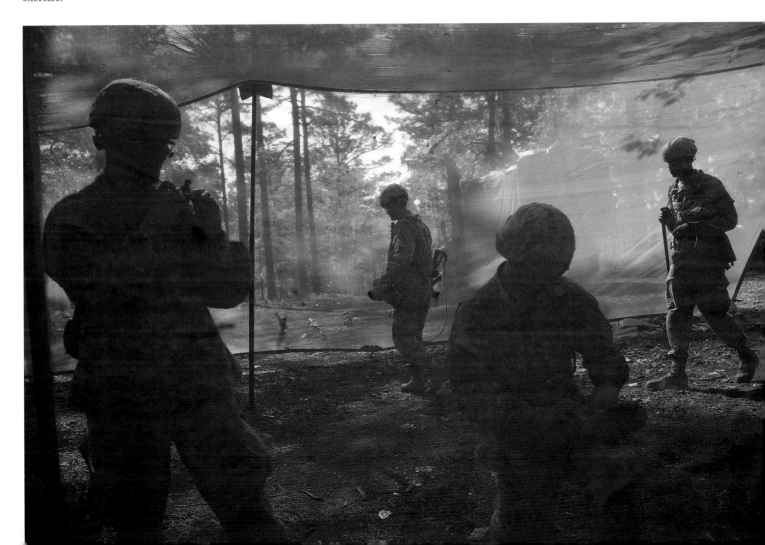

Recruits run through the forest during a training exercise.

Fort Benning is located on 182,000 acres in South Georgia outside of Columbus. Multiday field exercises take place in some of the more remote areas of the base.

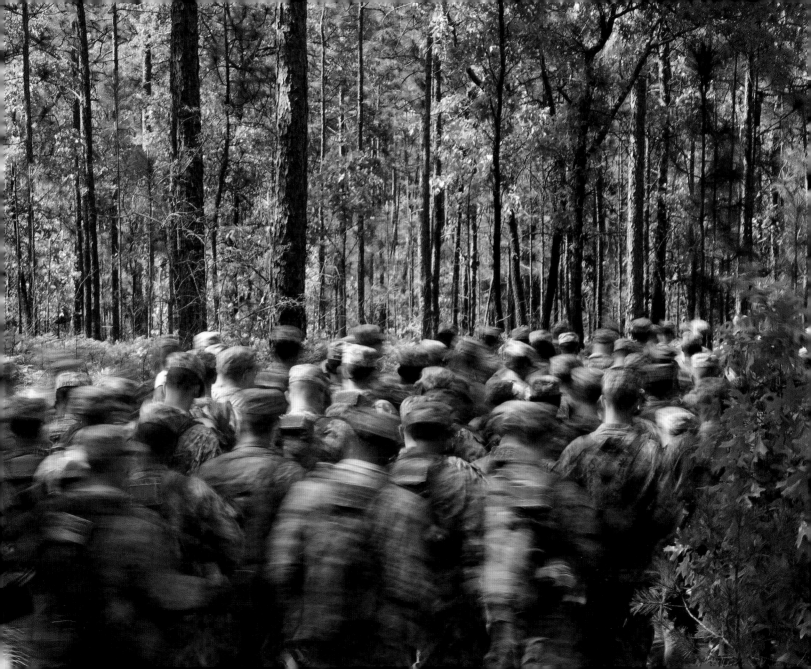

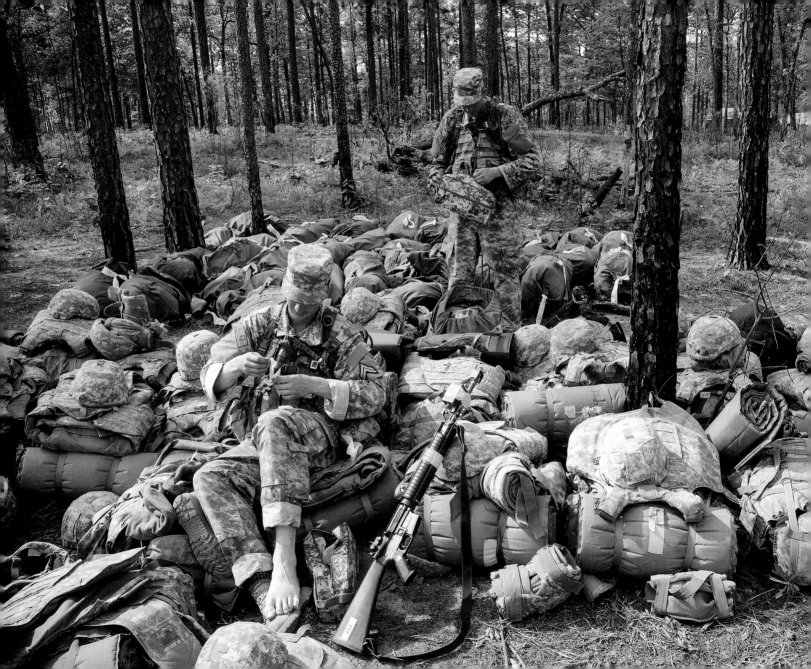

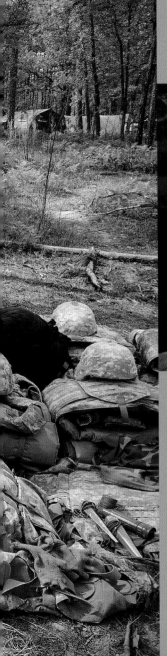

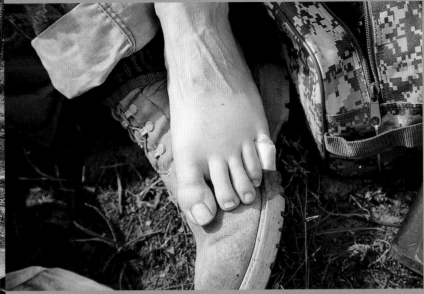

The most common injuries among recruits during basic training are foot injuries.

Two recruits wait for the drill sergeant's orders during a field training exercise.

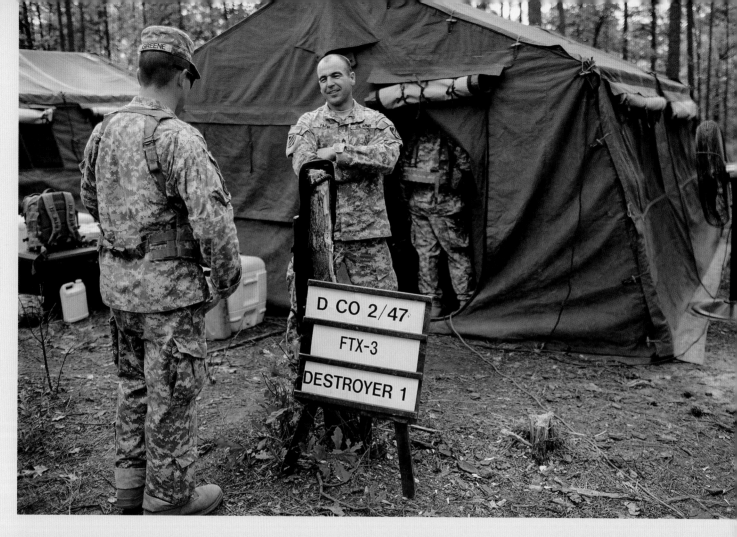

Drill sergeants talk outside their tent
during a multiday field exercise.

Drill sergeants gather in a tent to
go over the day's plan.

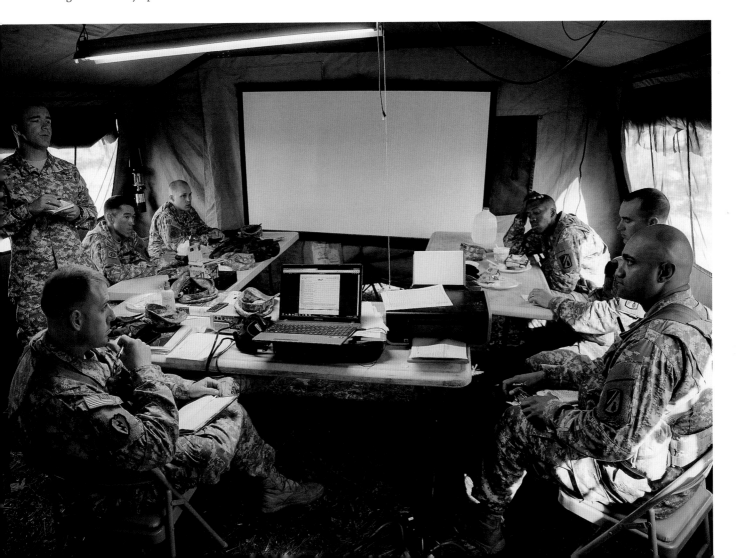

A recruit sorts through his gear
as he prepares to camp.

A recruit falls asleep
while holding watch in
his foxhole.

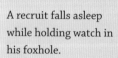

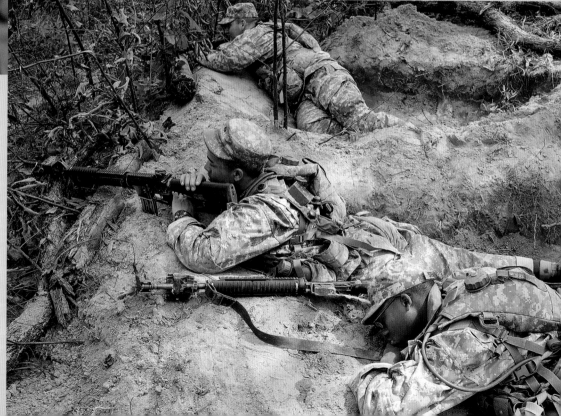

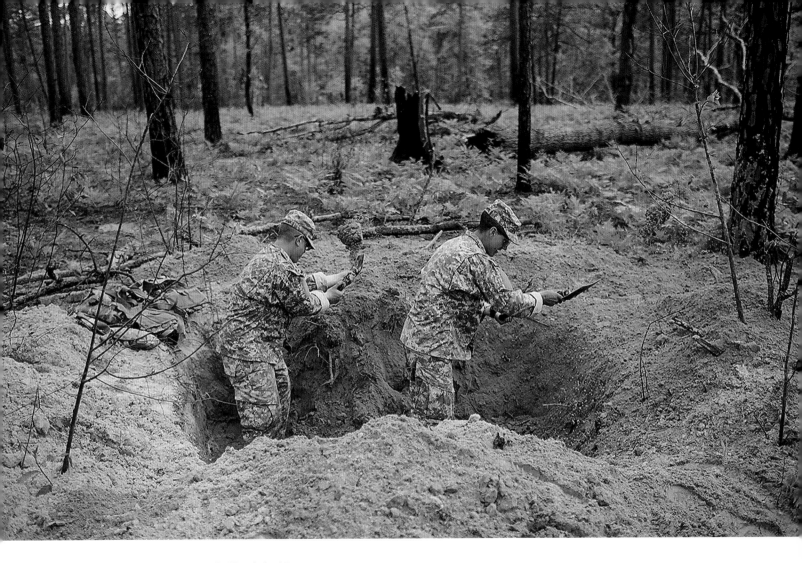

Recruits dig foxholes in pairs called battle buddies.

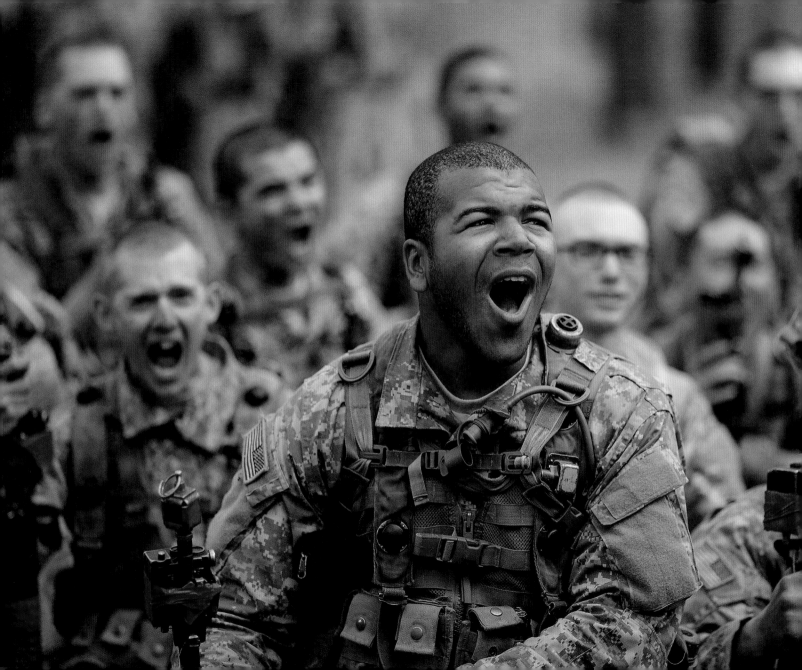

Recruits respond to a drill sergeant with a resounding "hooah," the universal reply for agreement or understanding.

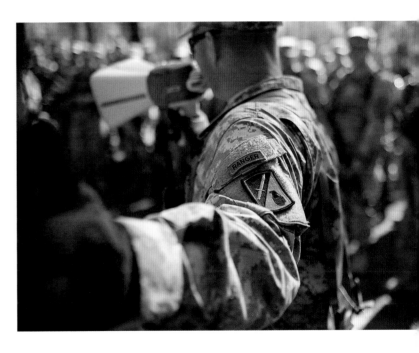

Capt. Donnie Bradford, the Delta Company commander, delivers orders.

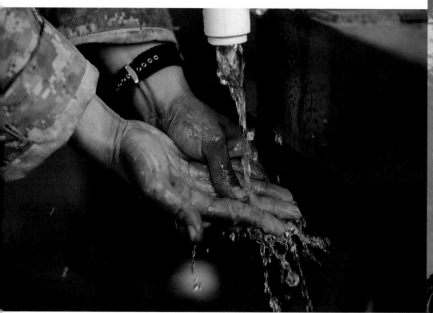

A recruit washes his hands while
in the field.

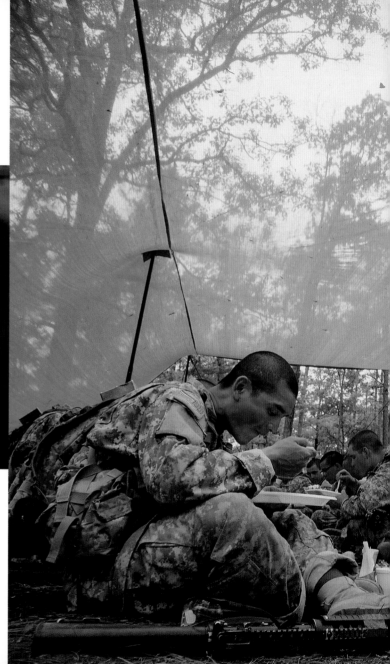

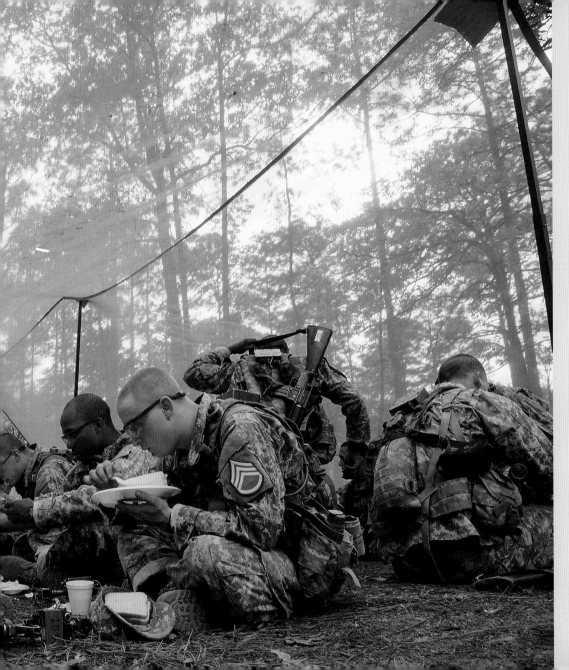

A platoon eats chow under
a shade tent in a remote
portion of Fort Benning.

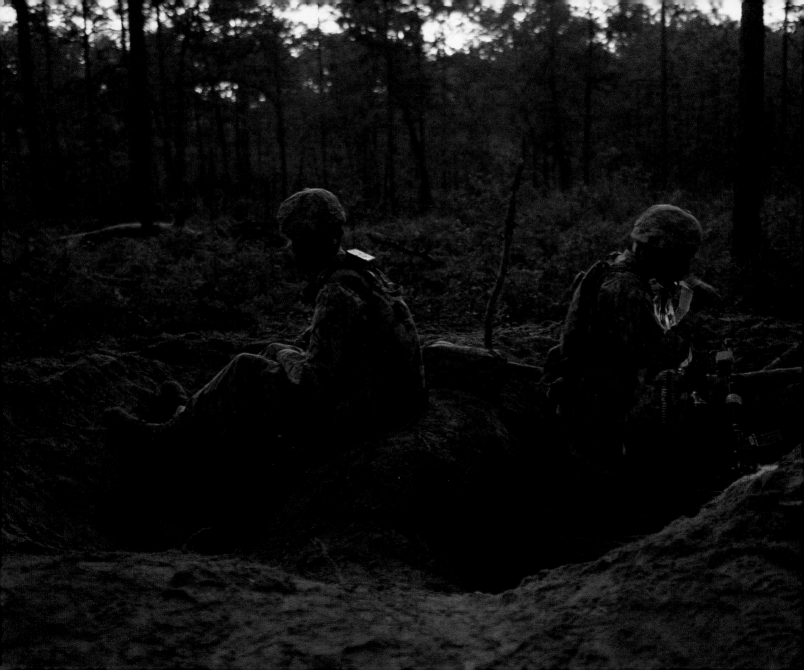

Recruits brush their teeth by the
light of their red safety lights after
spending the night in the field.

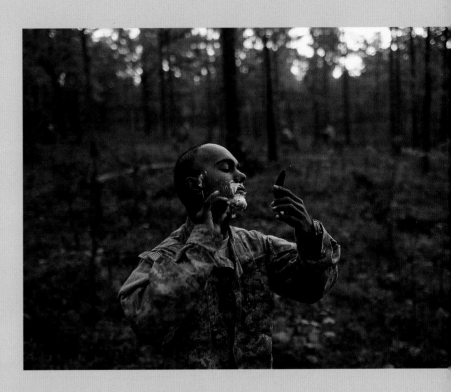

A recruit shaves in the early morning
hours after sleeping in the forest during
a field training exercise.

Two recruits wait for the drill sergeant's orders during an exercise.

A recruit tells a story using his entrenching tool shovel.

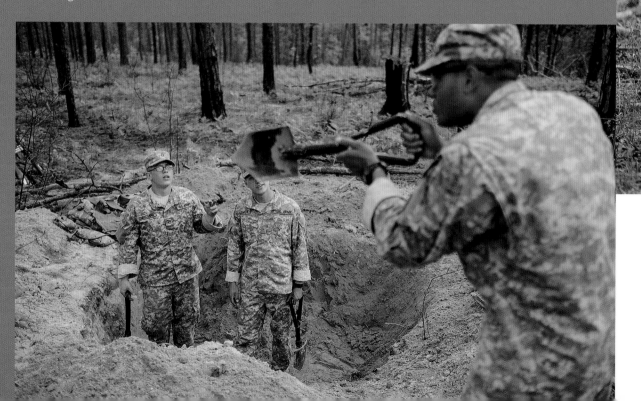

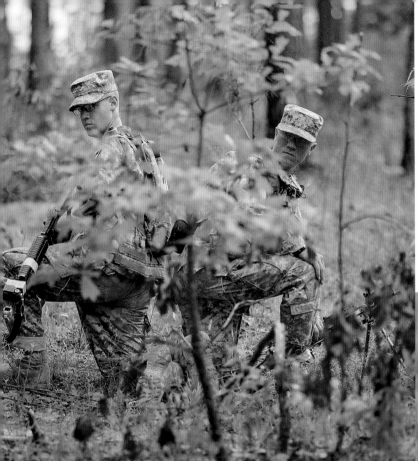

Recruits practice drills as a squad using real-world combat scenarios.

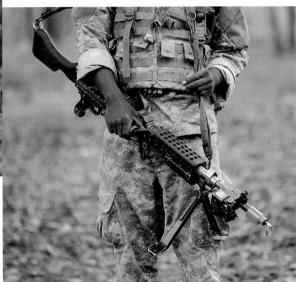

Recruits march back to Sand
Hill and the home of Delta
Company after many days
training in the field.

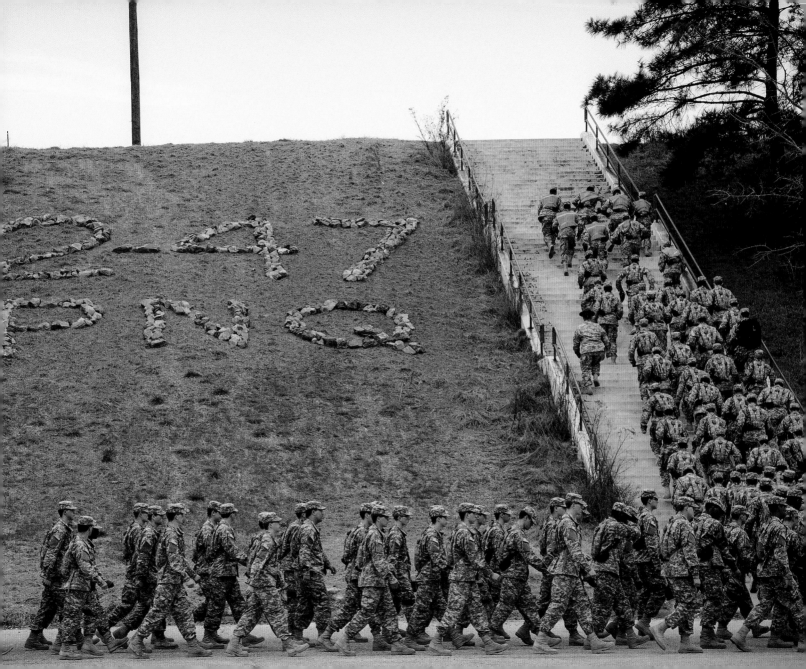

A drill sergeant leads recruits in PT.

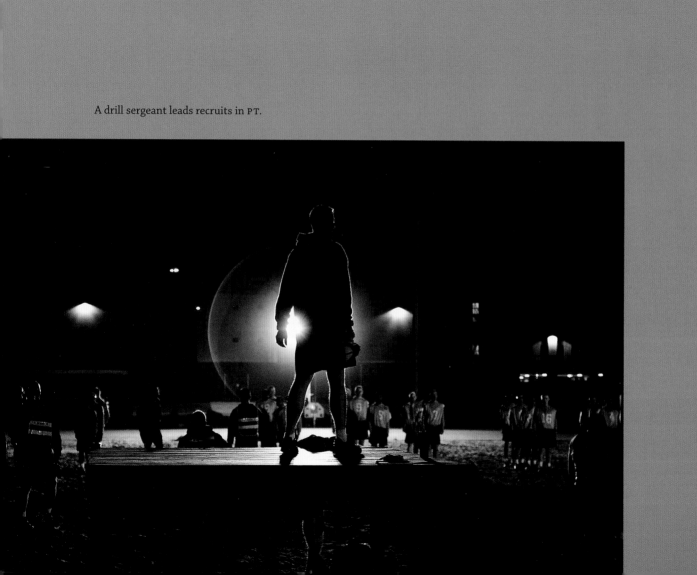

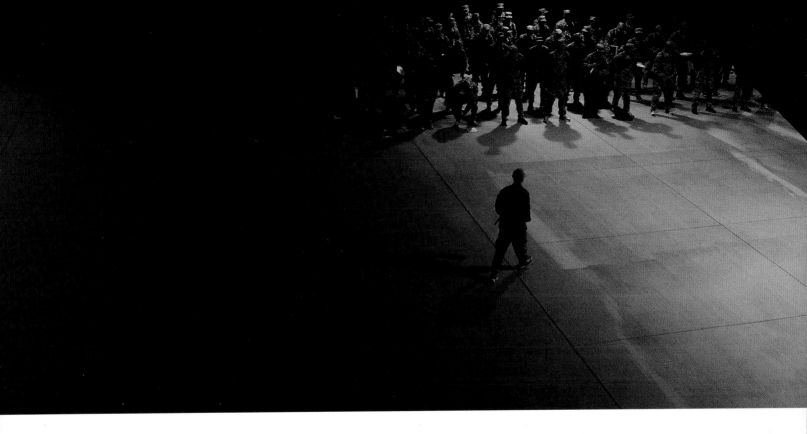

Recruits line up on the concrete pad outside of the
barracks well before dawn.

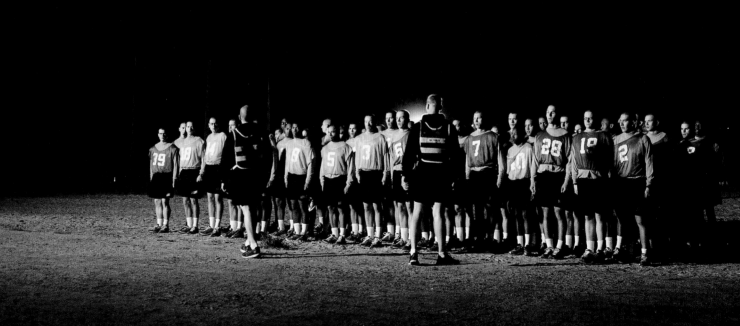

Recruits line up with a
drill sergeant.

Recruits are pushed to their limits with
consistent PT so they will be able to pass
the basic training physical fitness test.

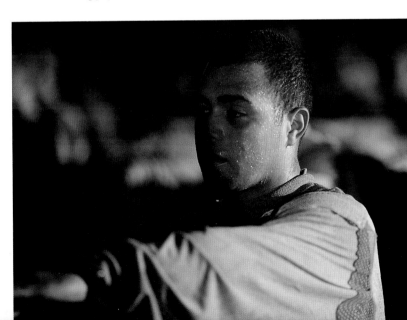

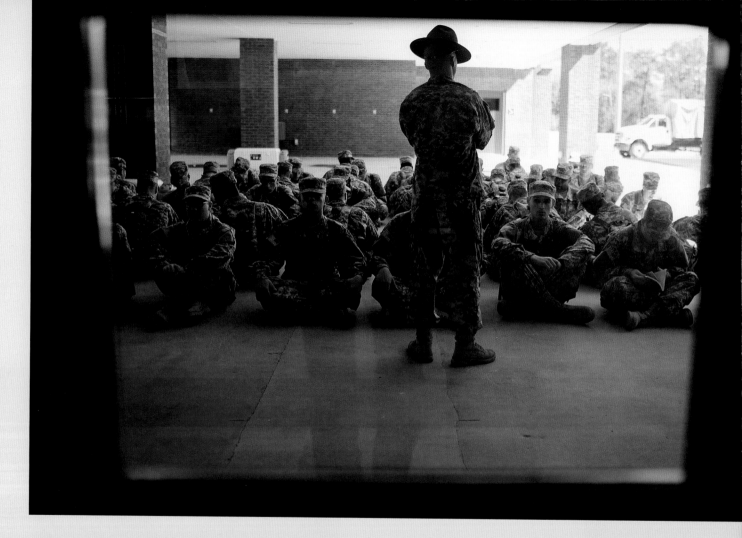

A drill sergeant talks to recruits at Delta
Company headquarters.

A drill sergeant sorts through mail.

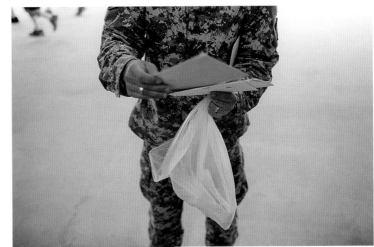

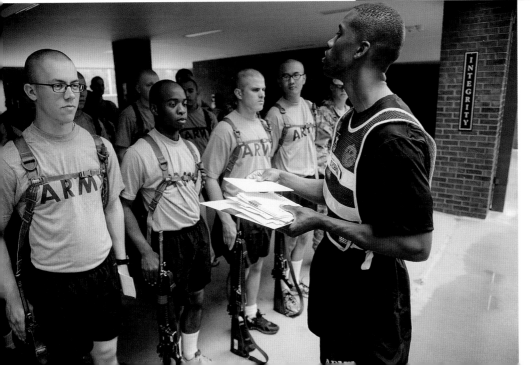

Mail is delivered to recruits during mail call, the daily delivery of mail.

Recruits break away and run
back toward base camp during
a field training exercise.

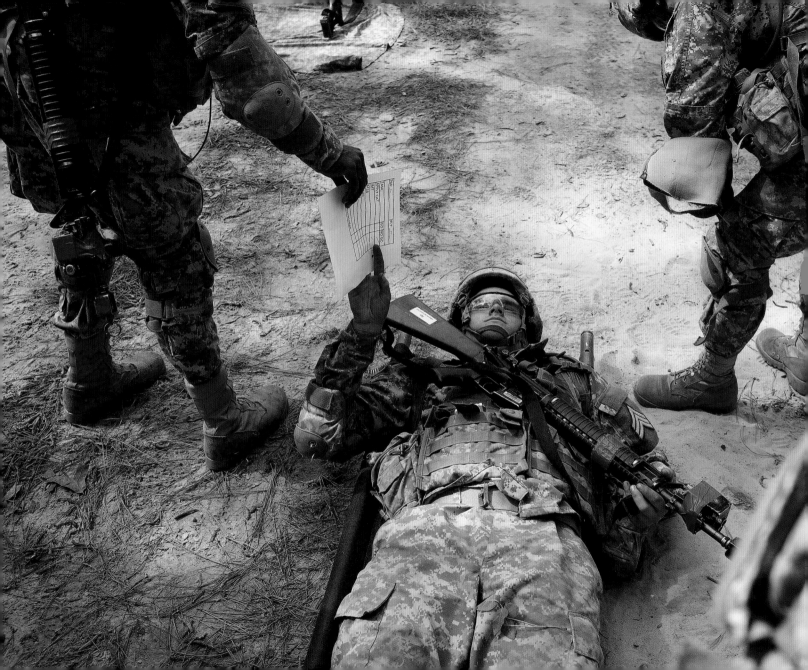

A sign in an area of the base set up as a makeshift Middle Eastern town where training exercises are conducted.

A recruit acts as an injured soldier during a field training exercise.

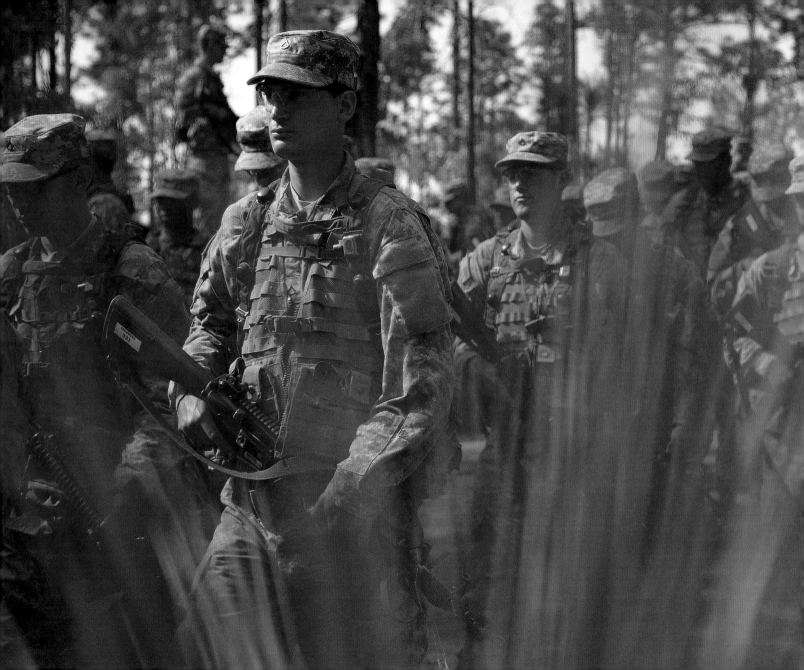

Recruits march through the forest during
a field training exercise.

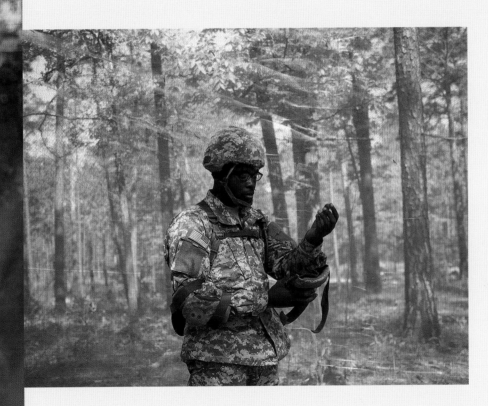

A recruit changes gear under the shade of a tent.

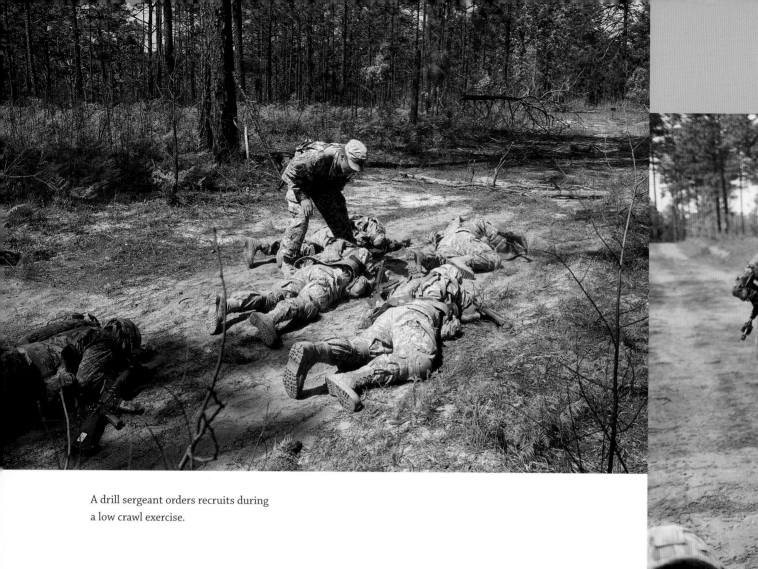

A drill sergeant orders recruits during
a low crawl exercise.

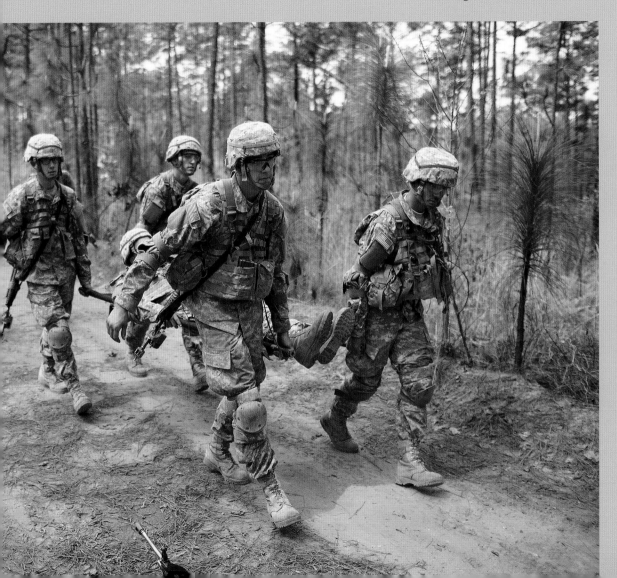

Recruits carry an "injured" soldier during a team exercise.

During mealtime in the field MREs (meals ready-to-eat) are often bartered and traded among soldiers.

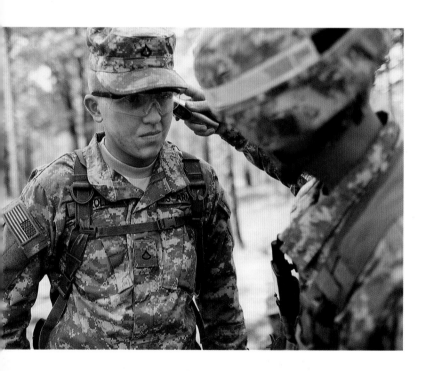

An overheated recruit has his temperature checked by a drill sergeant while he waits to be taken to sick call.

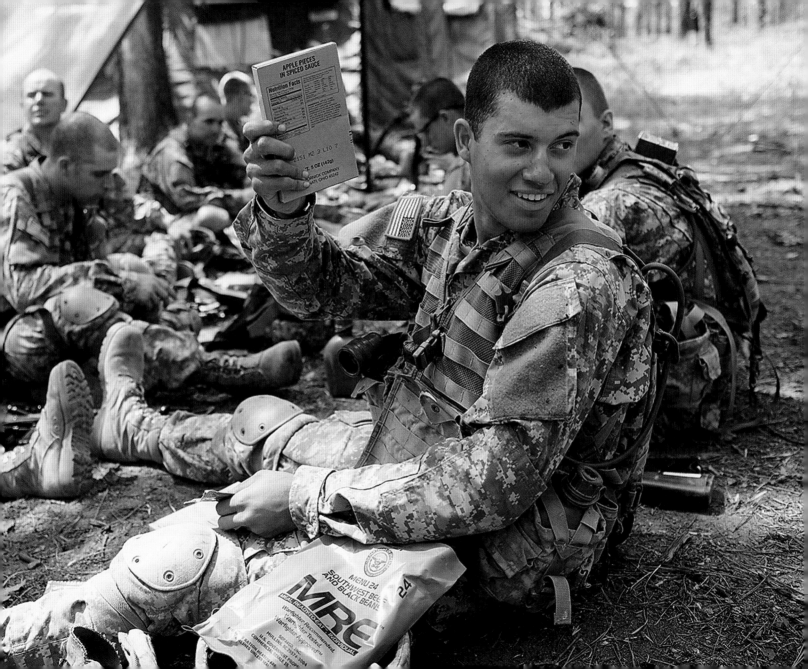

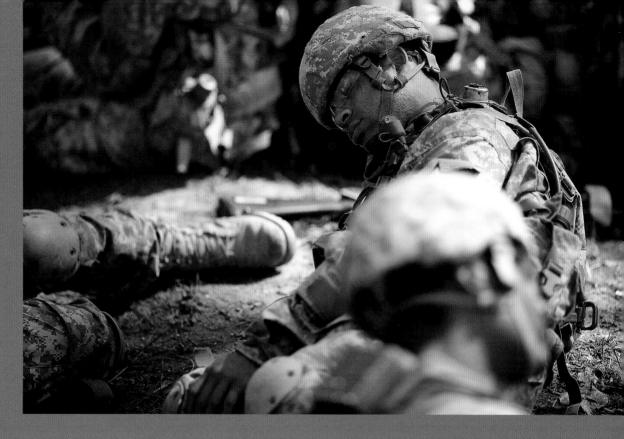

A recruit dozes off while studying a navigation
exercise under a shade tent.

Recruits practice with radio communication.

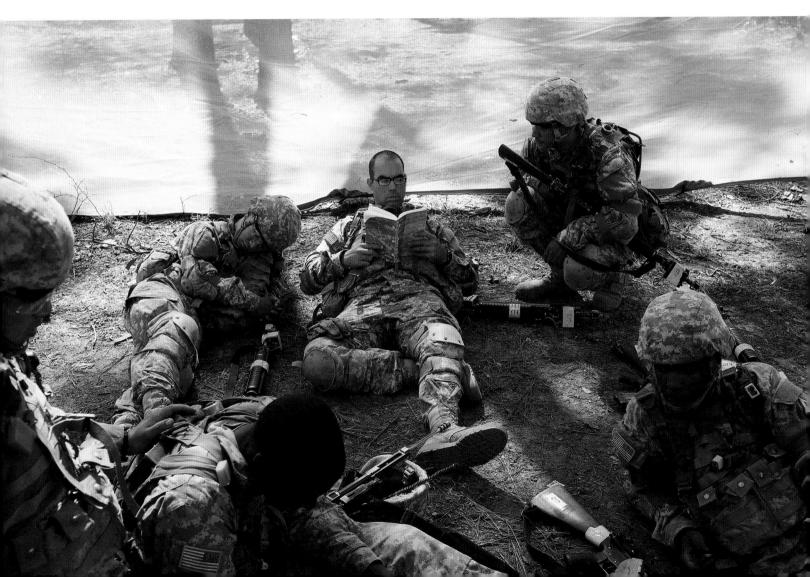

An injured recruit is
accompanied by a battle
buddy as they walk
through Delta Company
headquarters.

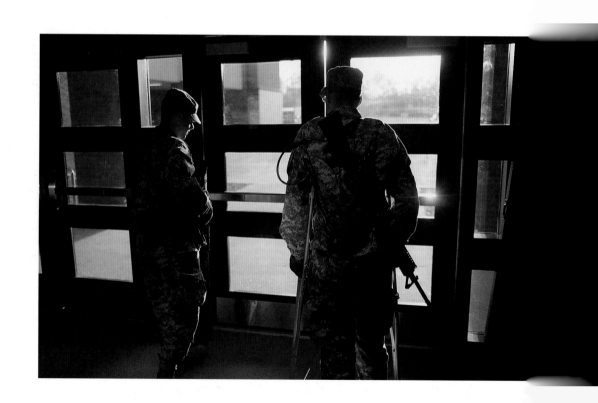

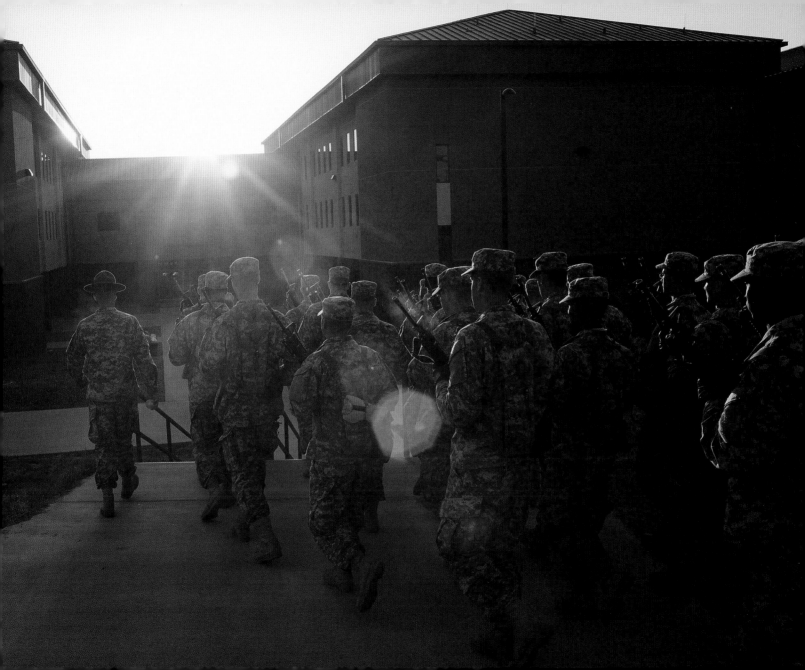

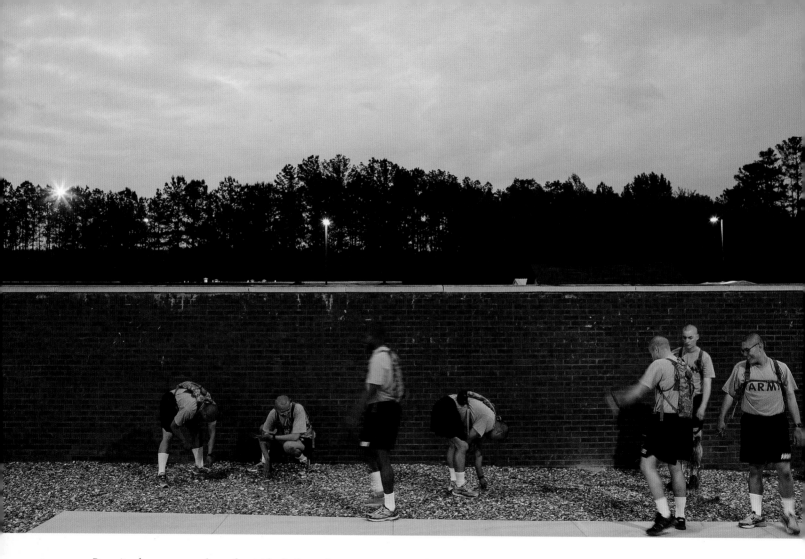

Recruits clean an area of gravel outside the barracks.

An injured recruit waits to be transported for a medical check.

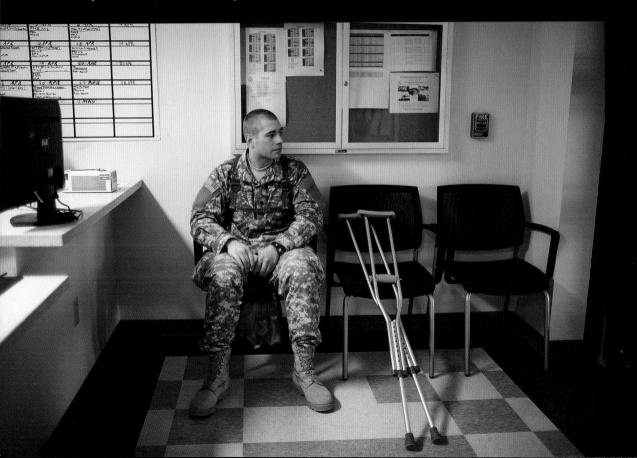

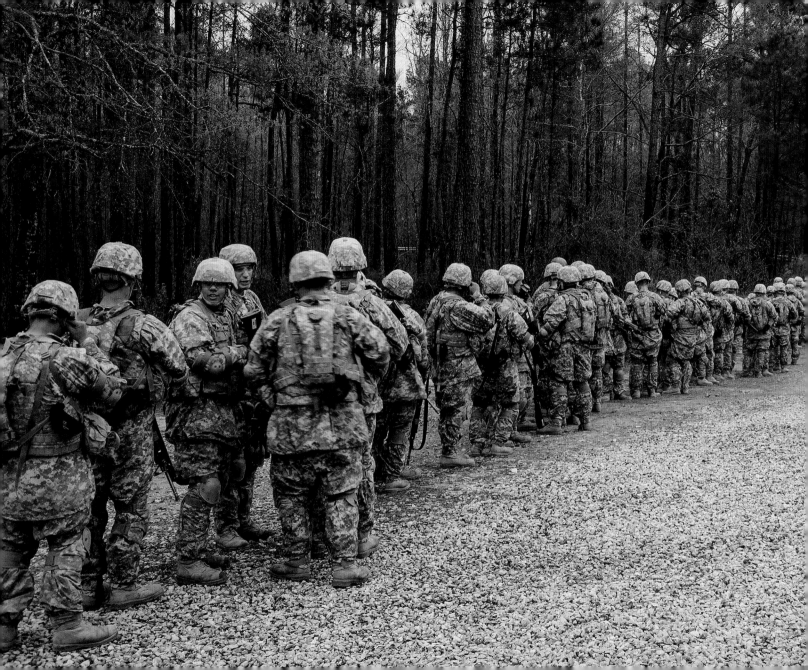

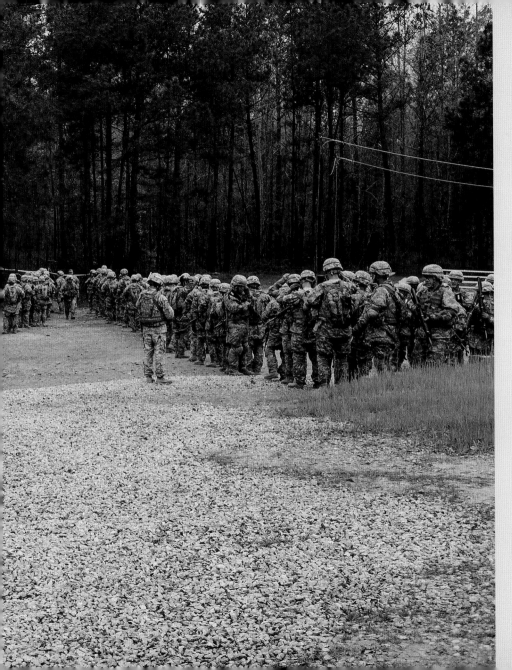

Recruits line up in full armored gear before a field training exercise.

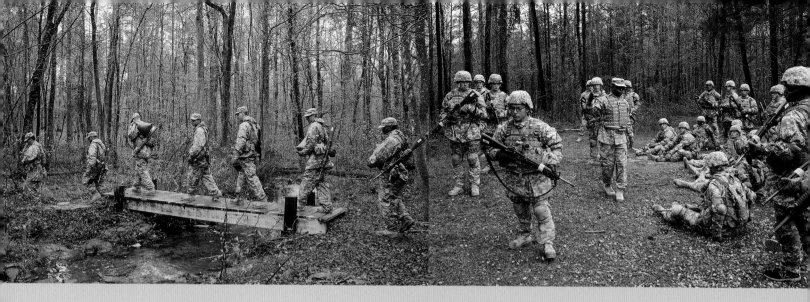

Recruits cross a wooden bridge while following a drill sergeant through the forest.

A drill sergeant instructs recruits on field combat tactics.

A drill sergeant illustrates a point to a recruit while the rest of the company waits in line for chow. The recruit had placed his American flag patch on his uniform upside-down, which is a distress code in the army.

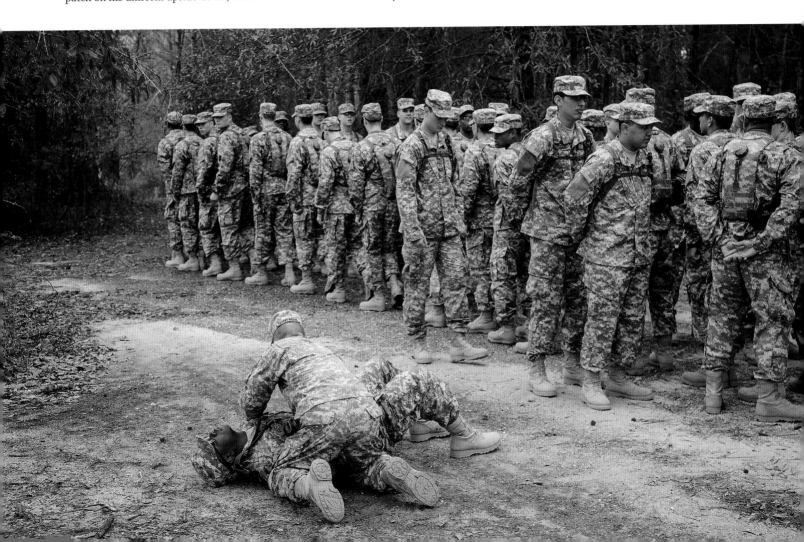

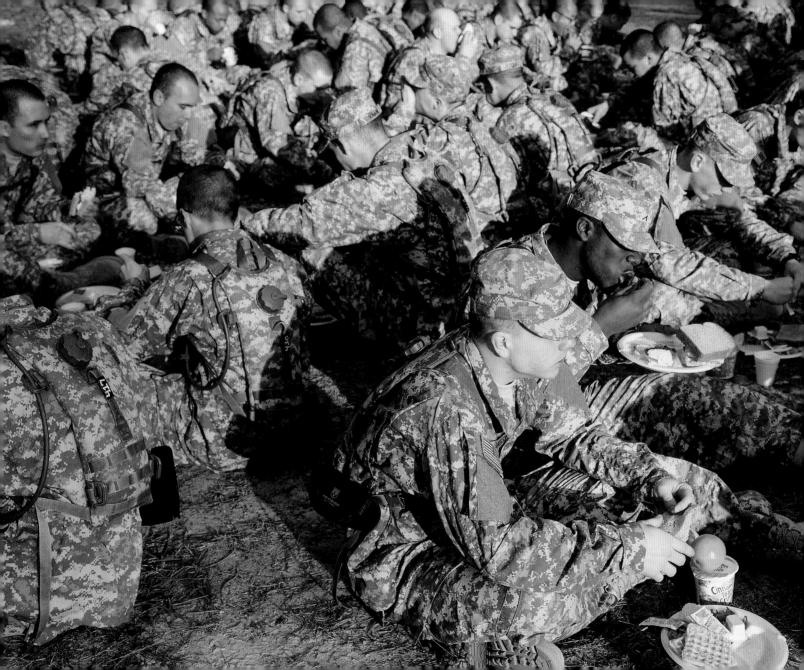

When eating chow in the field, soldiers sit on the ground in back-to-back formation.

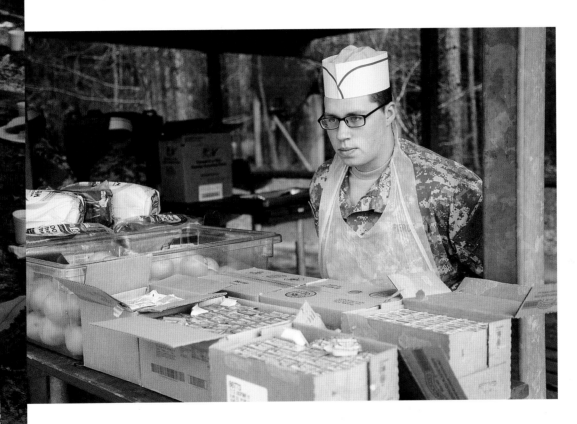

Recruits wait to begin serving chow in the field.

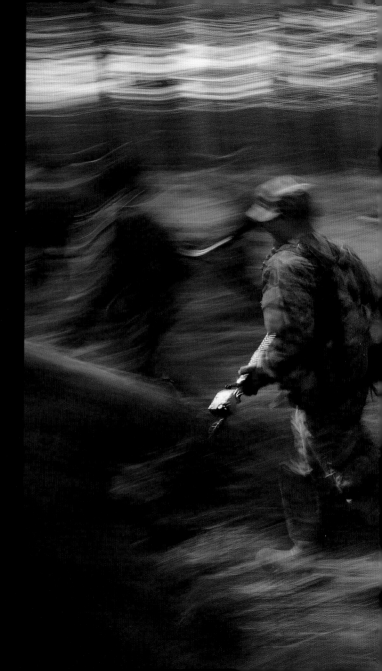

Recruits run through a forest
section of Fort Benning during
a team combat exercise.

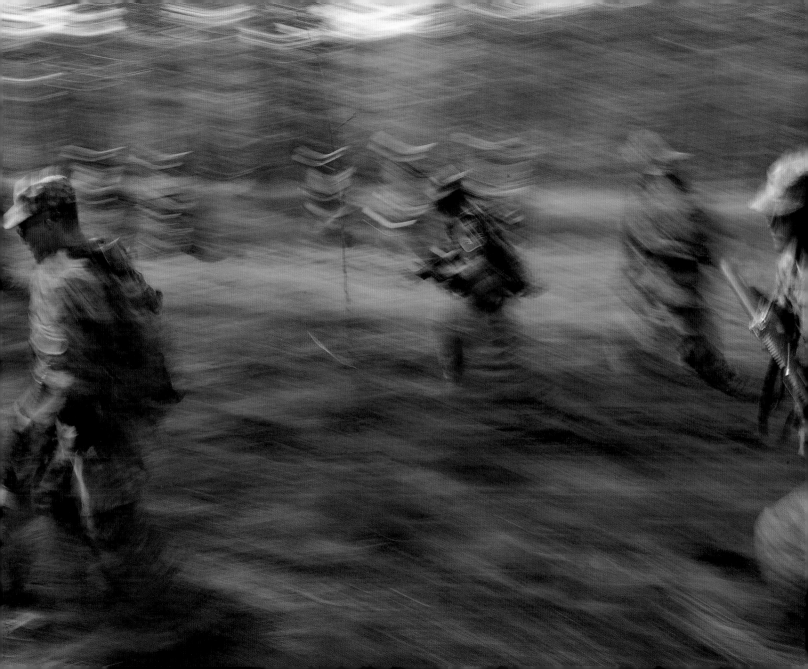

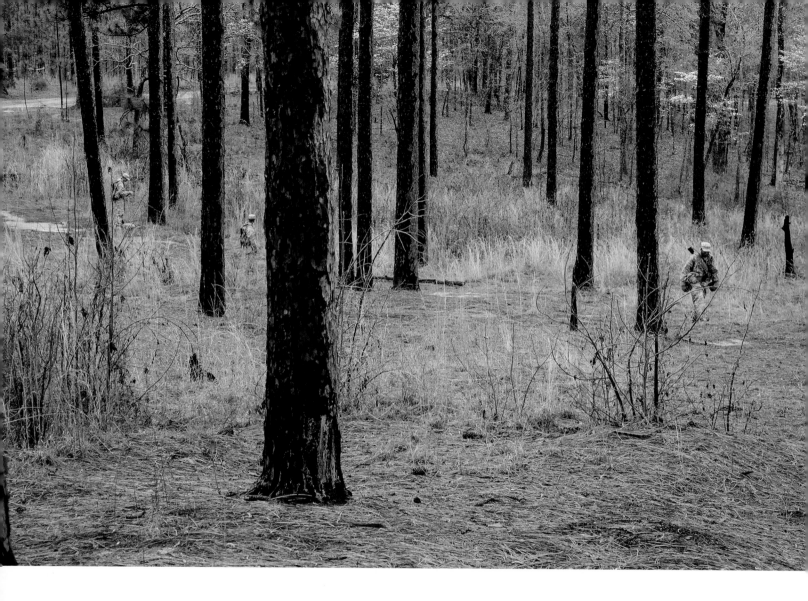

Recruits walk through a clear
forest area.

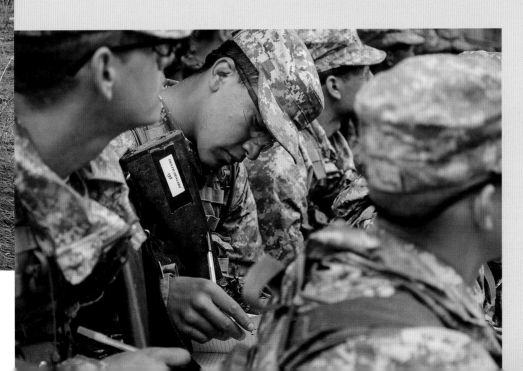

Recruits take
notes during a field
classroom session.

A drill sergeant holds class in an outdoor structure as recruits
begin an all-day field training exercise.

Recruits listen to instruction from a drill sergeant
while another does pushups.

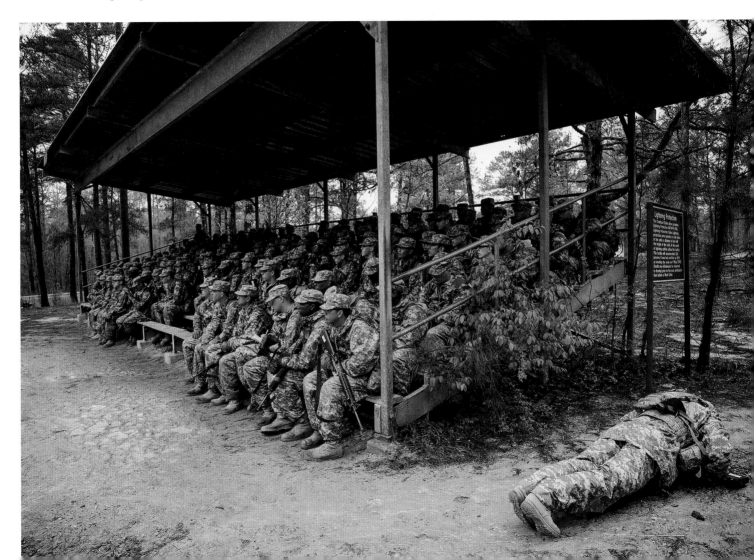

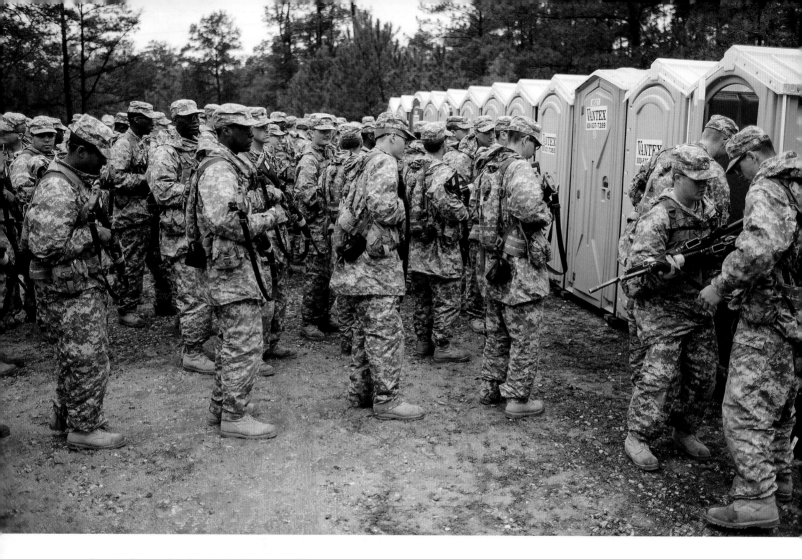

Recruits line up for a latrine break in the field.

Recruits find a rare moment to joke while waiting to use portable latrines during field training.

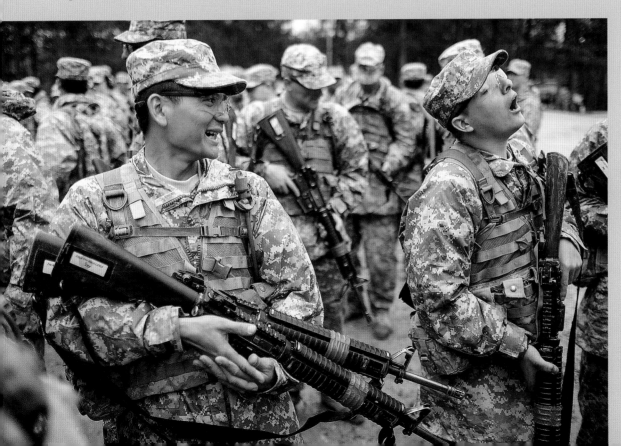

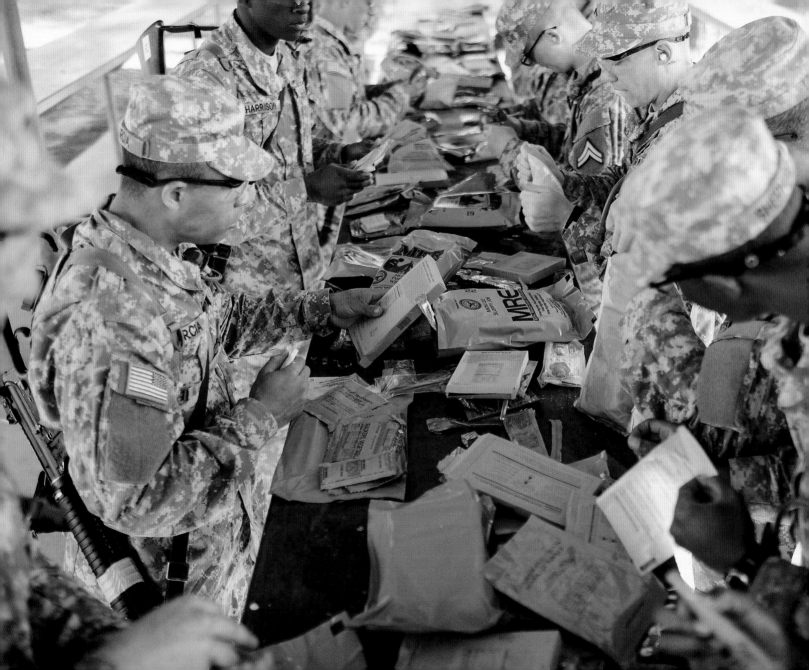

Recruits unpack MREs and sort through
the contents during chow.

Meals ready-to-eat.

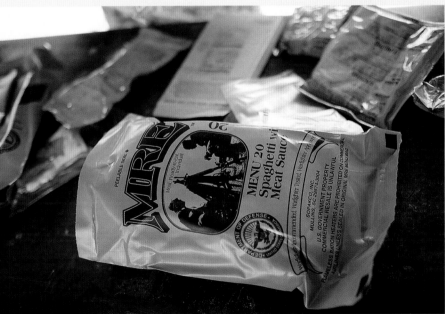

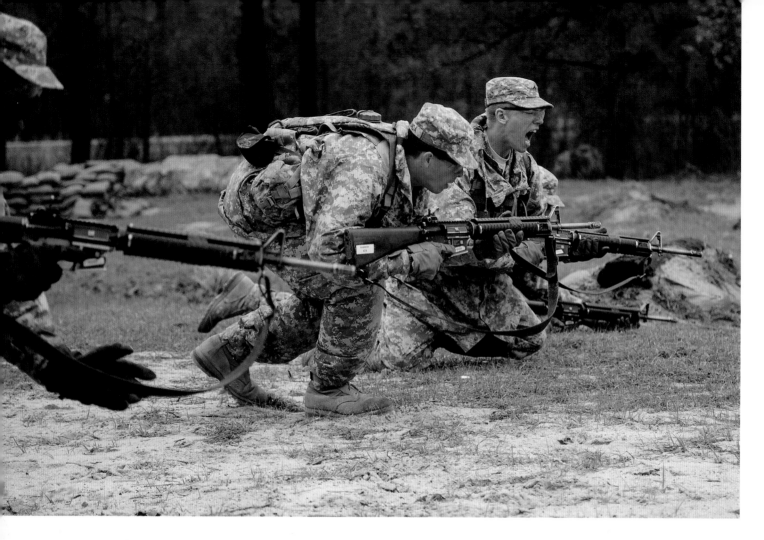

A squad of recruits advance on bad guys
during a training exercise.

Recruits count off and kneel to the ground during an inspection. To ensure that all soldiers are accounted for, platoons must always count off for a drill sergeant or squad leader before changing locations.

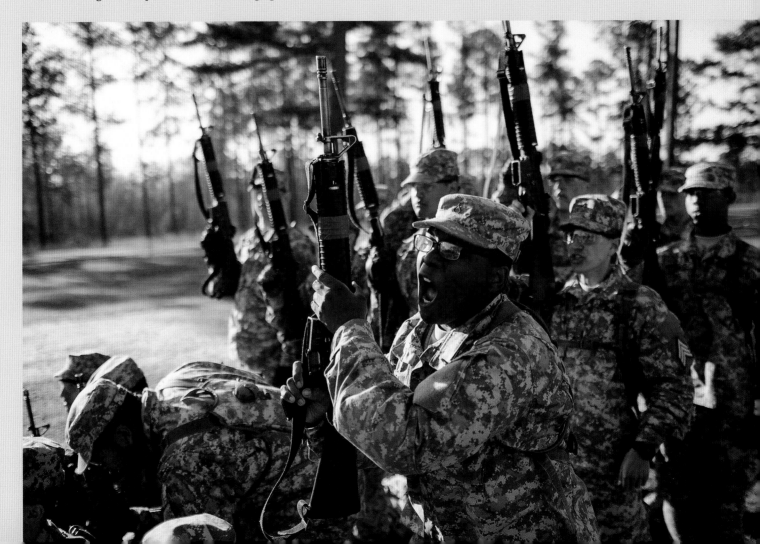

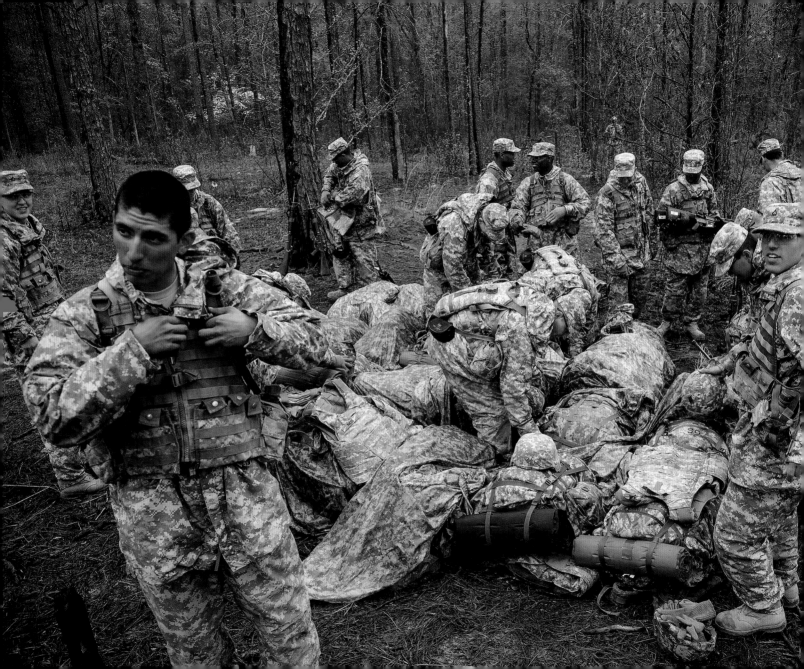

Recruits unload some gear before embarking
on a training exercise in the forest.

Platoons from Delta 2/47 march through
the forest at Fort Benning.

Recruits wait on a set of bleachers
before beginning a nighttime live-
fire exercise, a culminating event
and one of the more dangerous and
intimidating for new recruits.

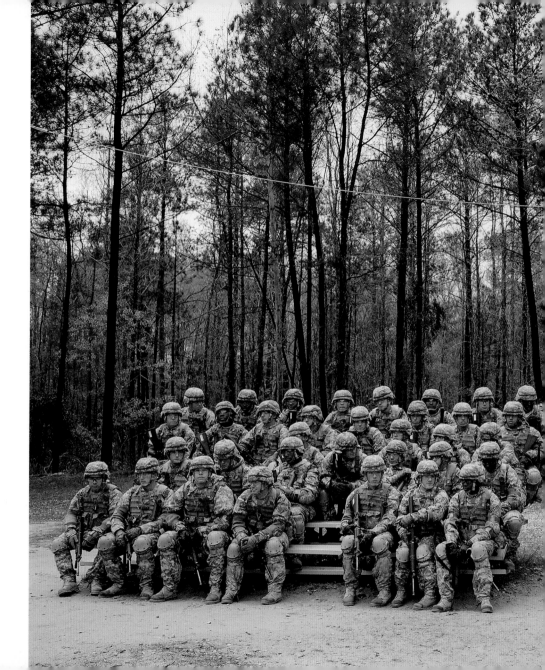

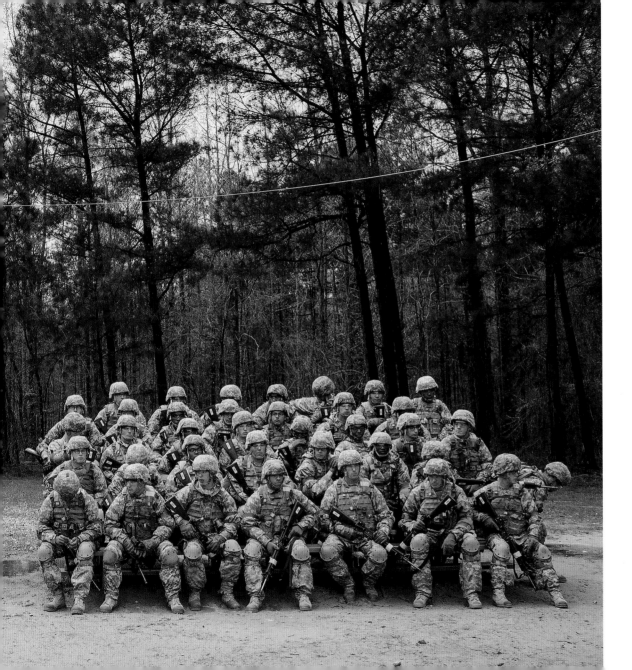

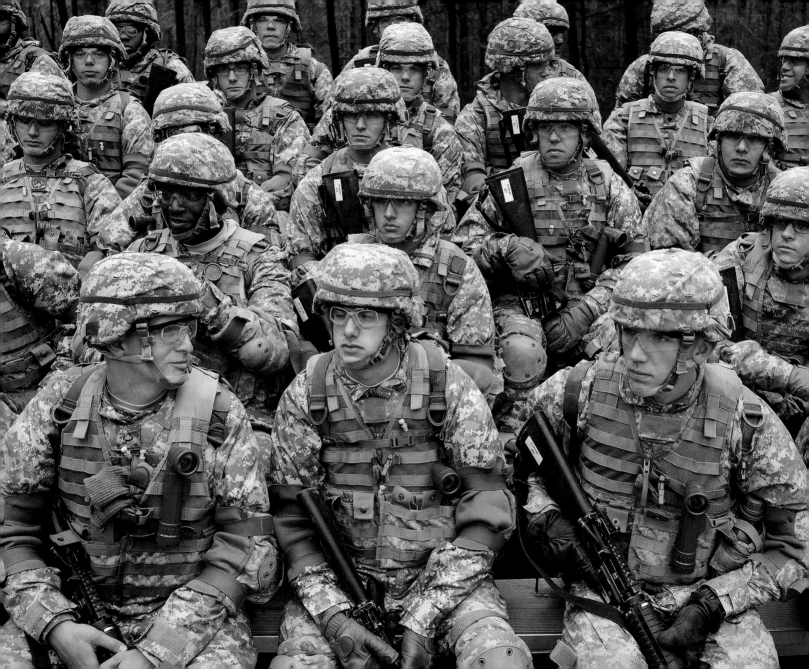

The 162 soldiers from Delta Company 2/47 sit
in formation on bleachers as they wait for orders.

Company commander Captain Bradford congratulates
several drill sergeants in his company on promotions.

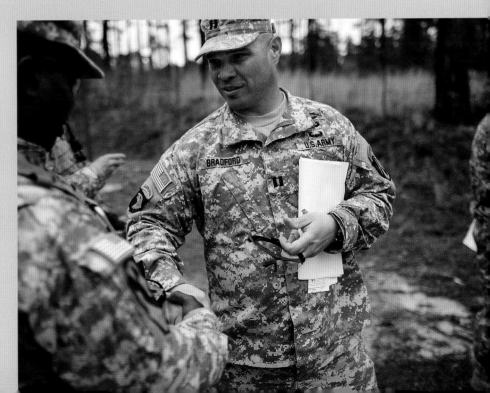

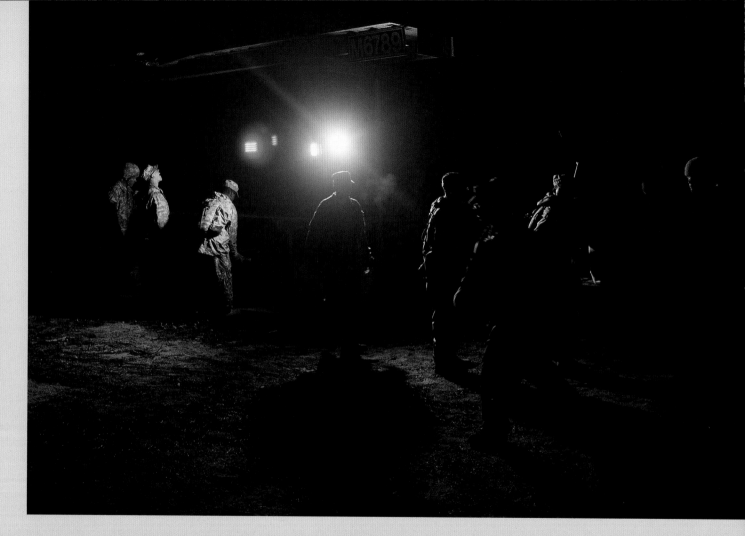

Recruits clean up after chow during an overnight
field training exercise.

Recruits struggle to set up personal tents
in the pitch-black forest.

Recruits sleep on the ground under
camouflage tarps.

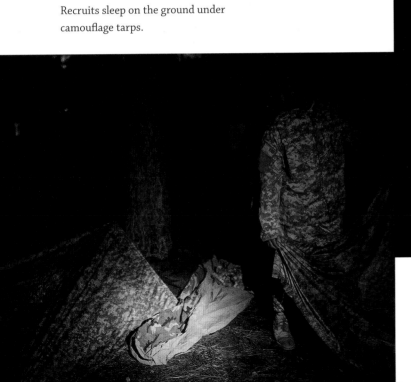

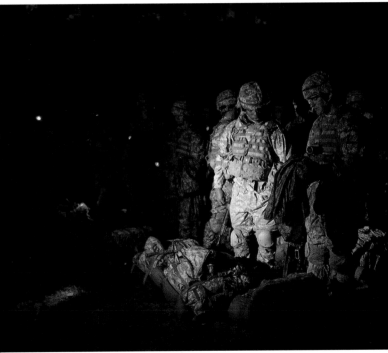

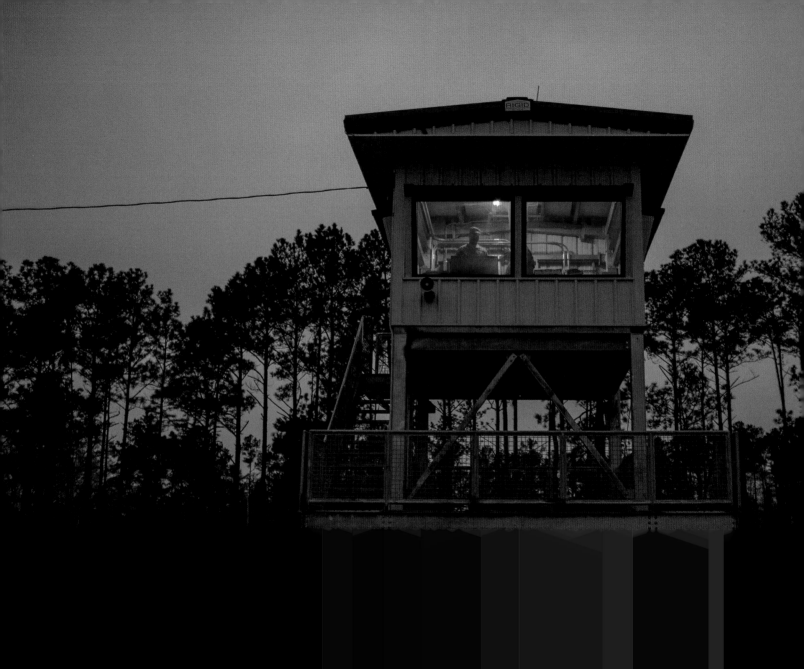

The control center for the night infiltration
course from which flares and explosions are
triggered is lit at dusk.

Live rounds and flares are fired overhead as
recruits crawl through a barbwire obstacle
course in the dark of night.

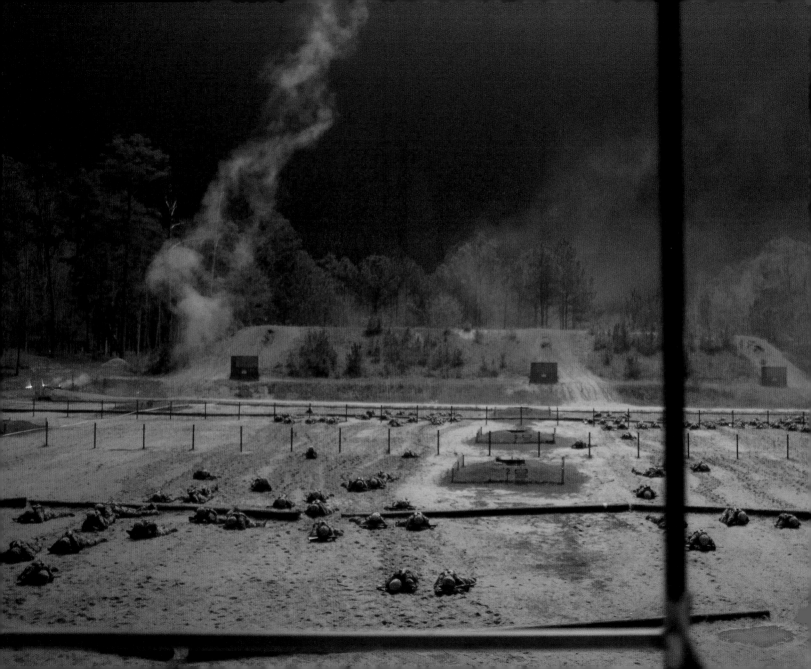

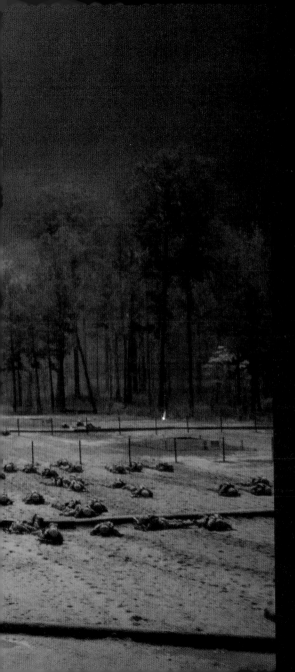

A flare, which simulates an incoming shell, lights up the night sky as recruits stop moving and take cover.

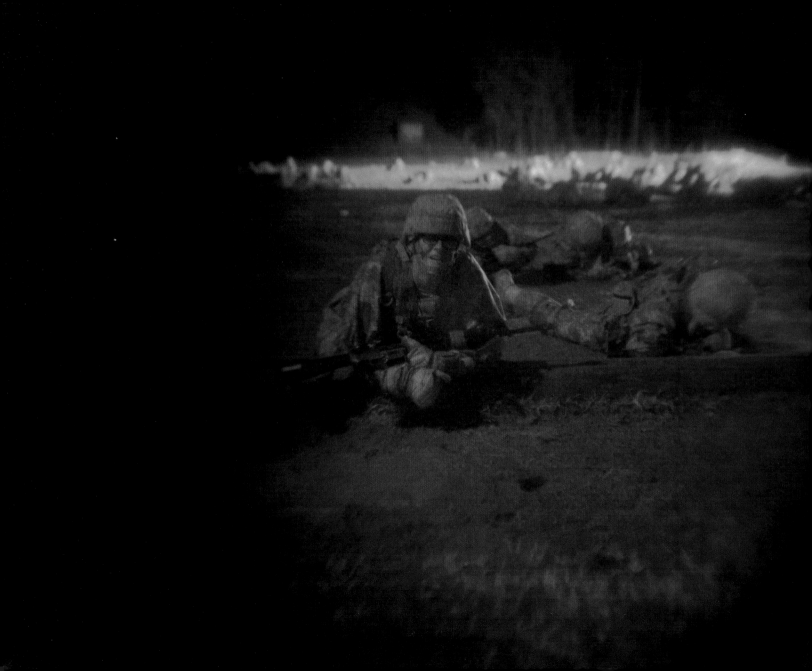

Recruits struggle to find their
bearings in the pitch-black night
as they complete the night
infiltration course.

A recruit jumps to his
feet as he nears completion
of the course.

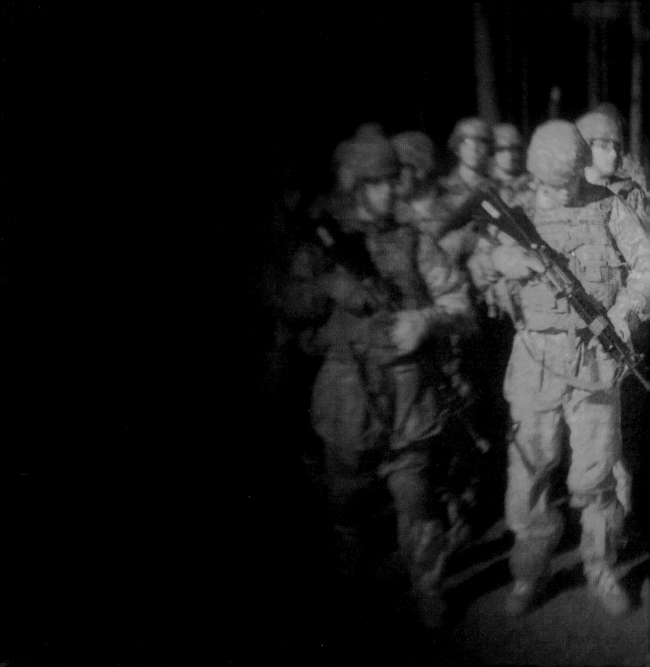

A night-vision photograph shows recruits lined up in formation after a nighttime live-fire exercise.

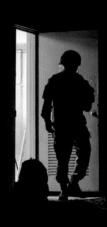

A drill sergeant leaves one of the buildings
on the night infiltration course as training for
the night is complete.

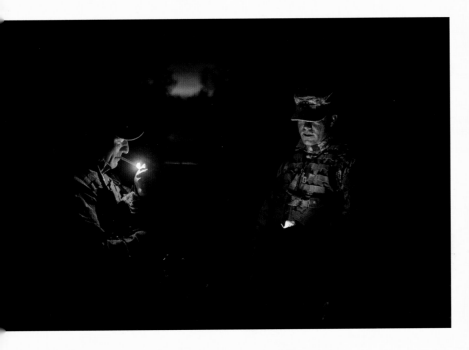

Drill sergeants are restricted from using cell phones
or smoking around recruits, but during a break in
the action two drill sergeants relax.

A recruit shows his family around the base.

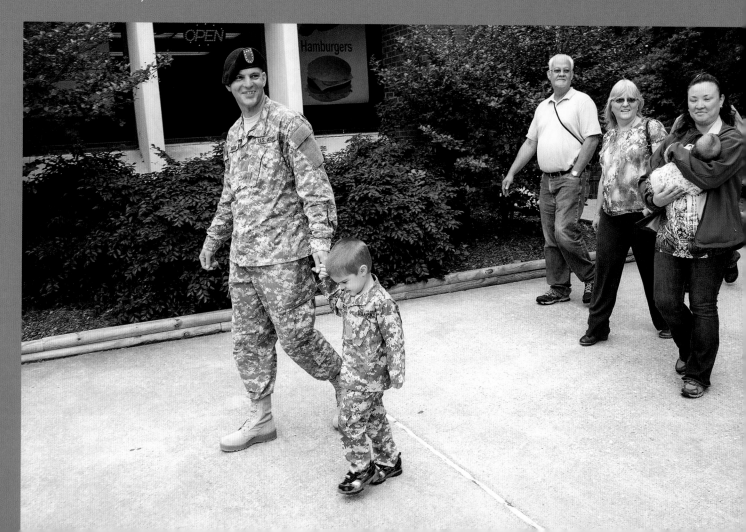

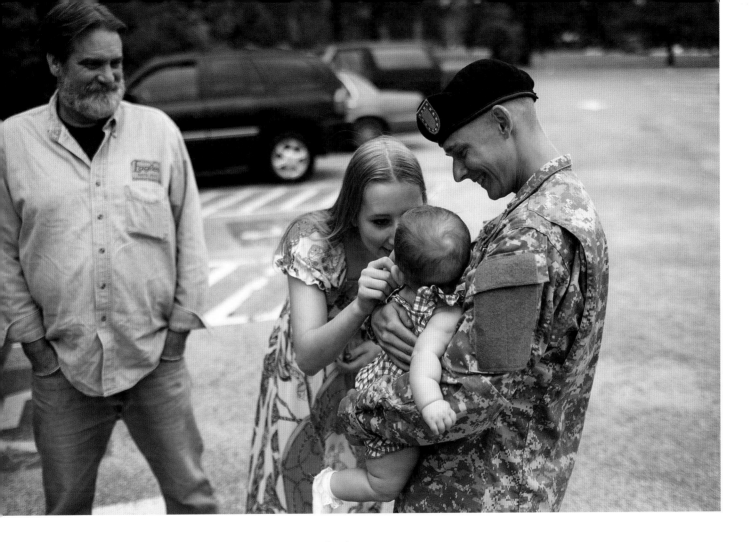

A recruit holds his baby daughter at Fort Benning on family day before graduation.

A recruit speaks to a family member using a mobile phone on family day.

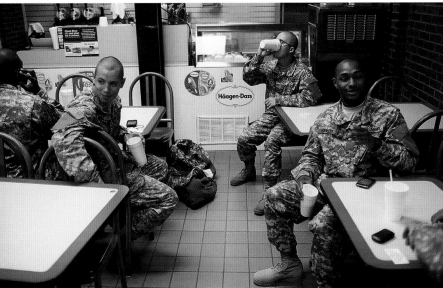

A group of recruits enjoy civilian food for the first time as they await the arrival of family members.

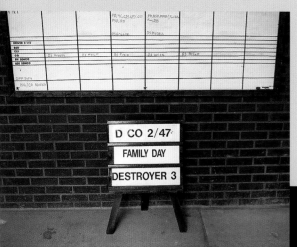

A sign indicating family day stands at the 2/47 barracks. Family day is the first visitation recruits receive from family in ten weeks and takes place the day before the graduation ceremony.

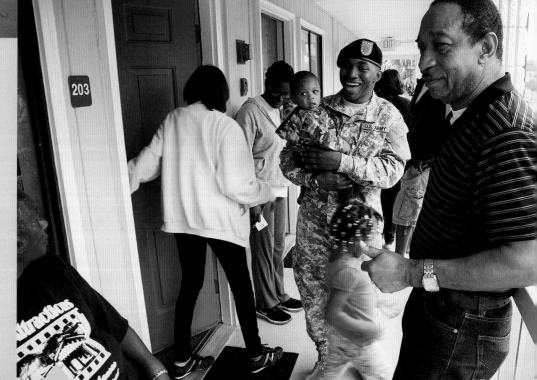

A recruit visits with his family at their hotel just off base.

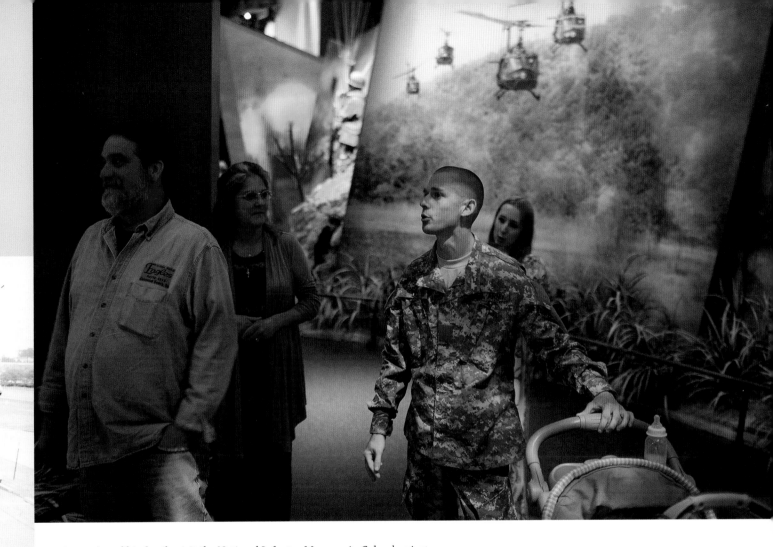

A recruit and his family visit the National Infantry Museum in Columbus just
outside of Fort Benning.

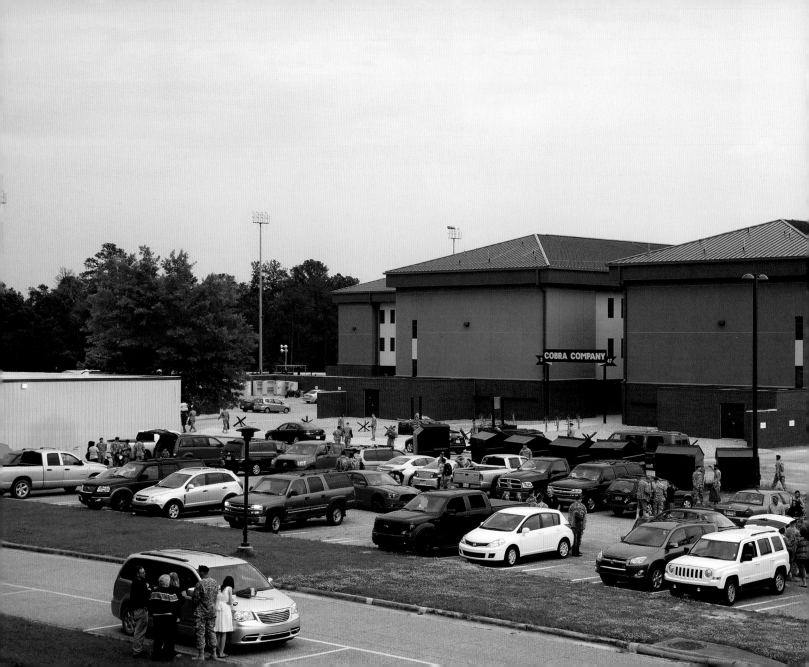

Recruits and their families fill
the battalion parking lot on
family day before graduation.

An infantry brigade yearbook sits on the
bed of a recruit in the barracks.

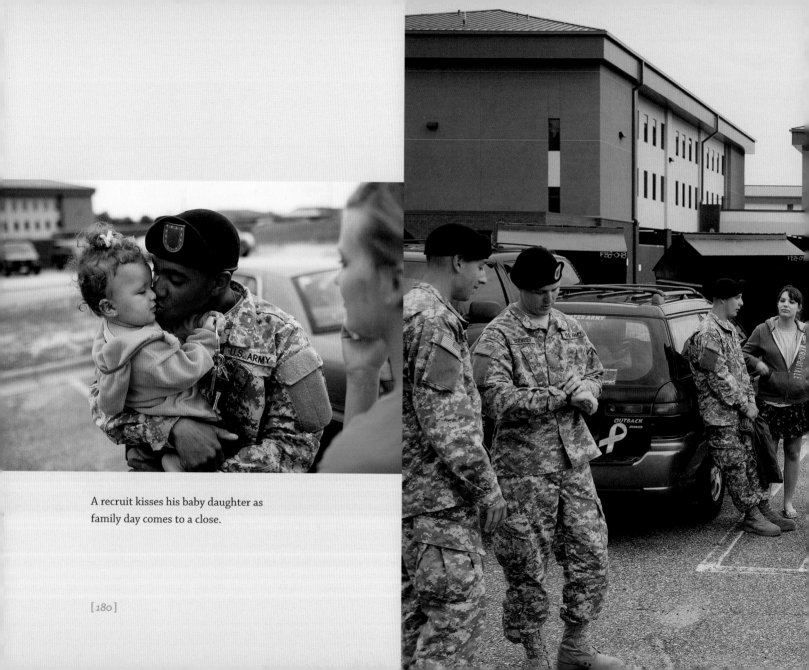

A recruit kisses his baby daughter as family day comes to a close.

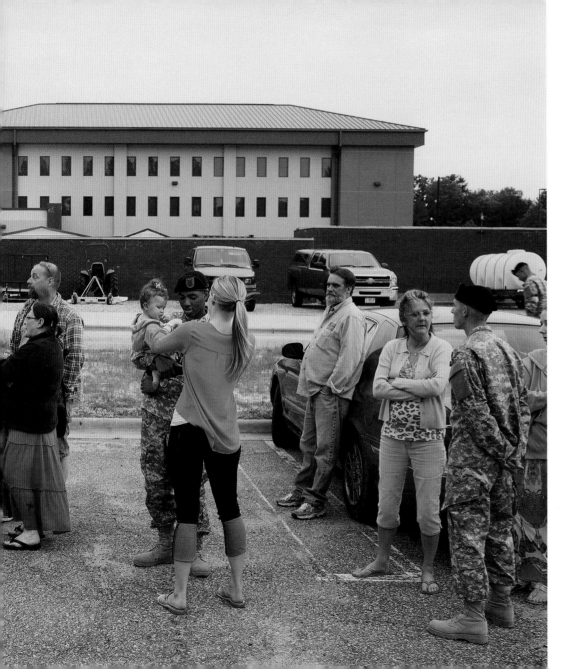

Recruits say good-bye
to family members as
curfew nears at the end of
family day.

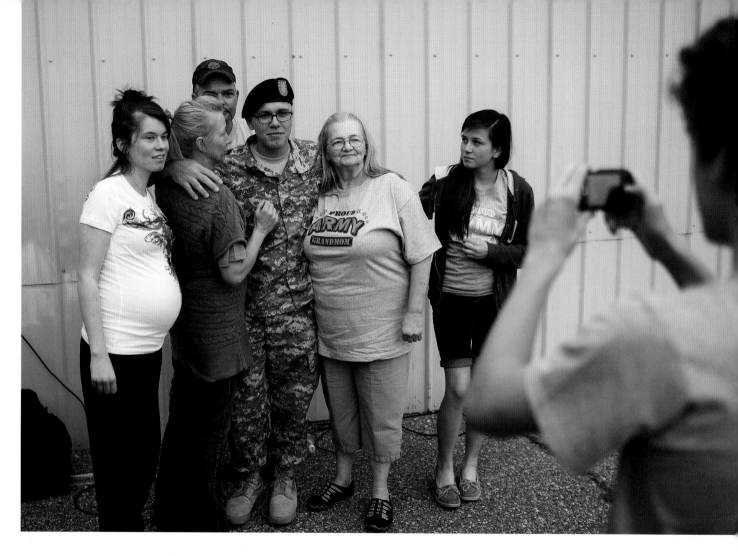

A recruit poses for a picture with family members.

A recruit says good-bye to his mother as family day comes to a close.

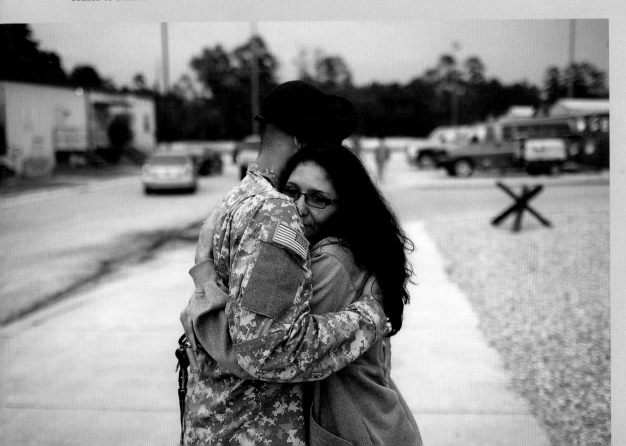

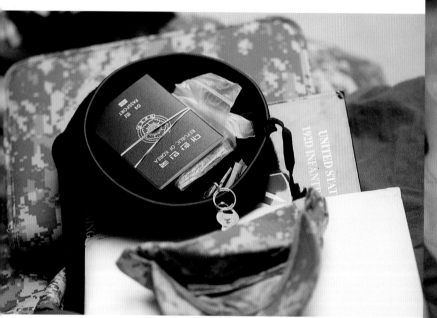

A recruit's South Korean passport and other belongings sit on the ground during inspection at the end of family day. The U.S. military has a "naturalization at basic training" program with certain countries, which allows noncitizen enlistees to expedite citizenship in exchange for service in the armed forces.

A recruit returning from time away with his family jokes with fellow soldiers.

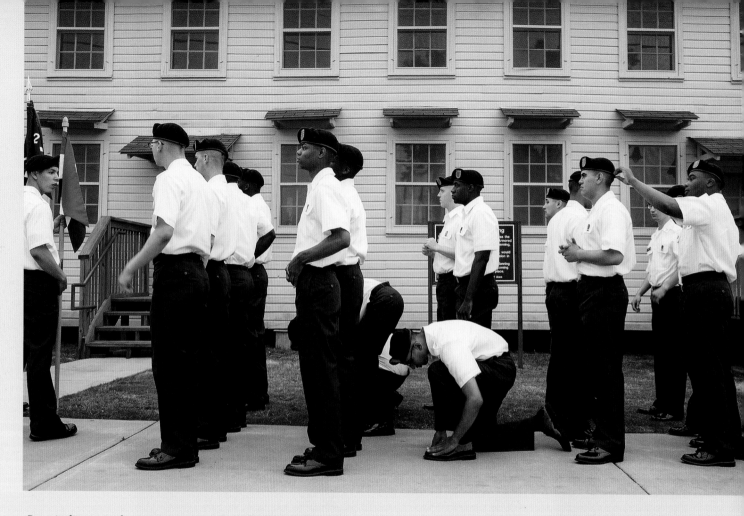

Recruits line up in the staging area near the National Infantry
Museum before beginning the graduation ceremony.

Recruits stand in formation at the parade field before marching in the graduation ceremony.

Recruits help straighten the beret of another as they tediously prepare their uniforms for graduation.

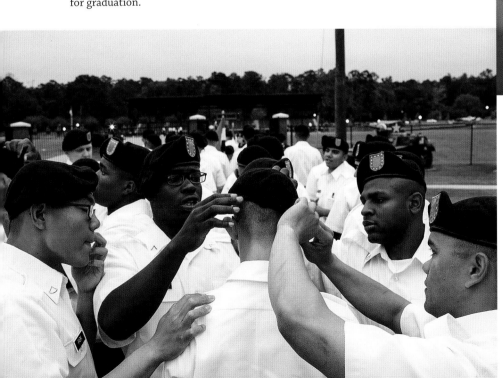

Recruits march across the
parade field adjacent to the
National Infantry Museum as
hundreds of family members
look on.

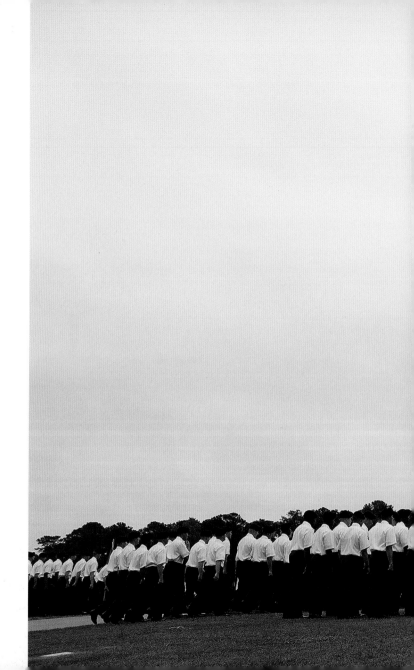

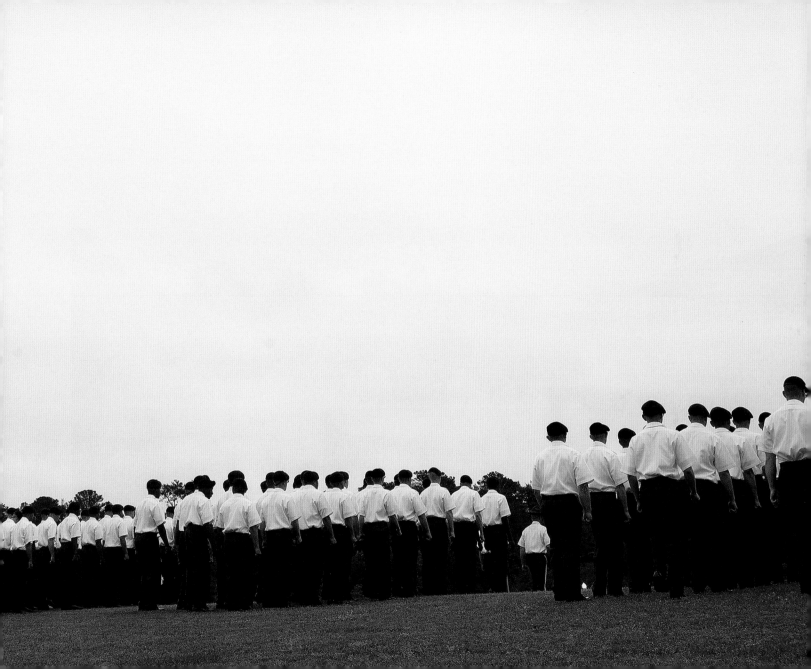

Recruits march off the field to meet their families after completing basic training and graduating.

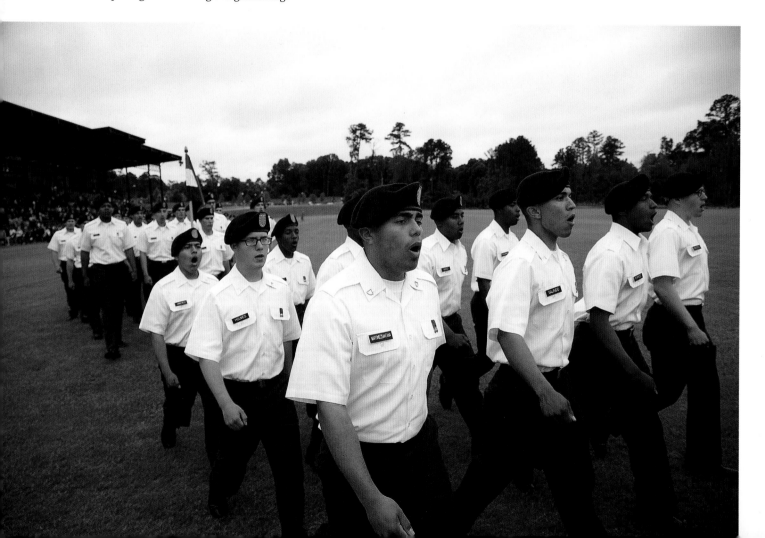

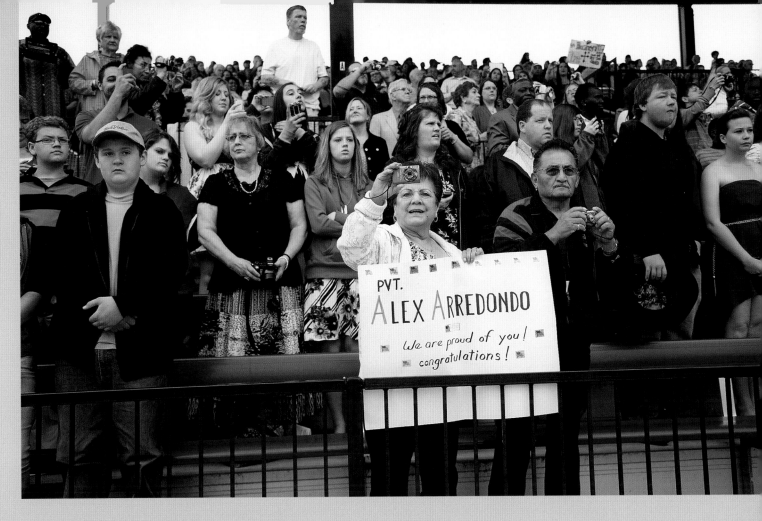

Family members watch as newly graduated recruits march
by at the completion of the ceremony.

The sign reads:

PVT. ALEX ARREDONDO

We are proud of you!
congratulations!

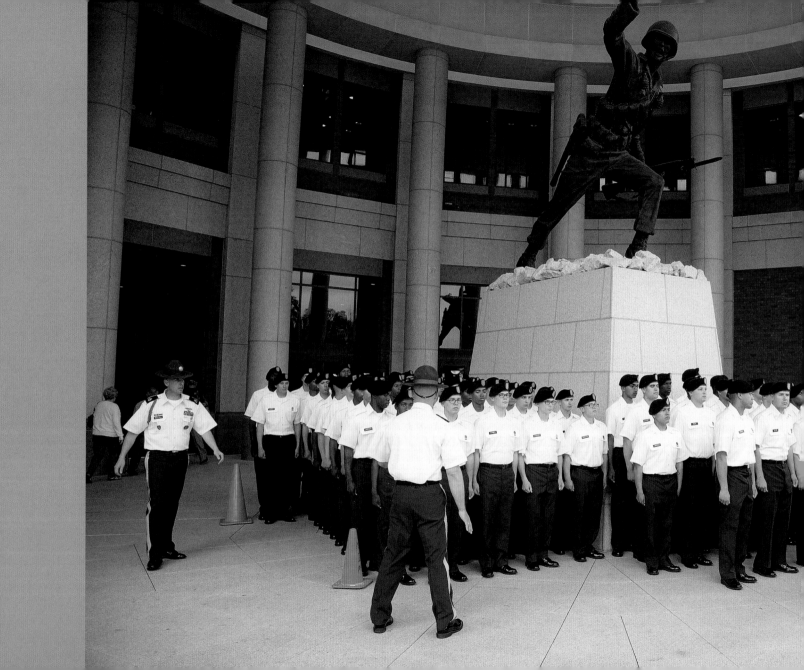

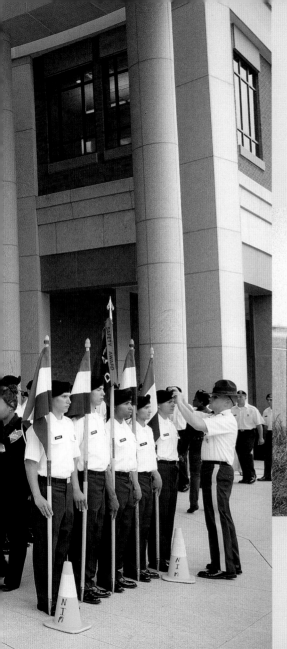

Delta Company 2/47 lines up for their
official group picture in the outdoor rotunda
of the National Infantry Museum.

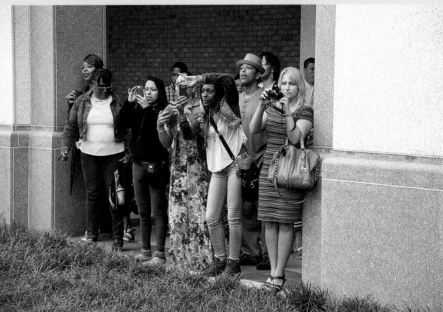

Family members eagerly attempt to take pictures
of their graduates after the ceremony.

A recently graduated U.S. Army soldier carries his son away after the graduation ceremony.

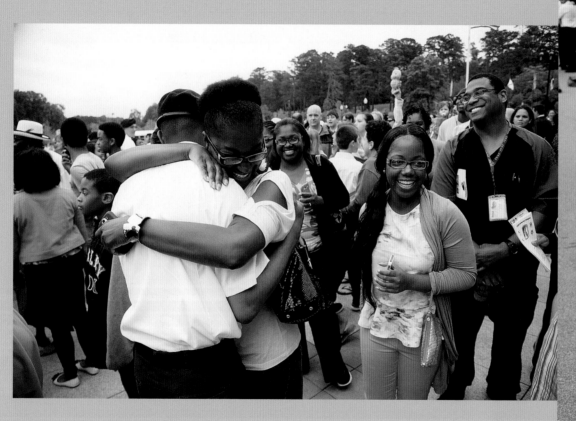

A recruit is embraced by family members as they reunite after graduation.

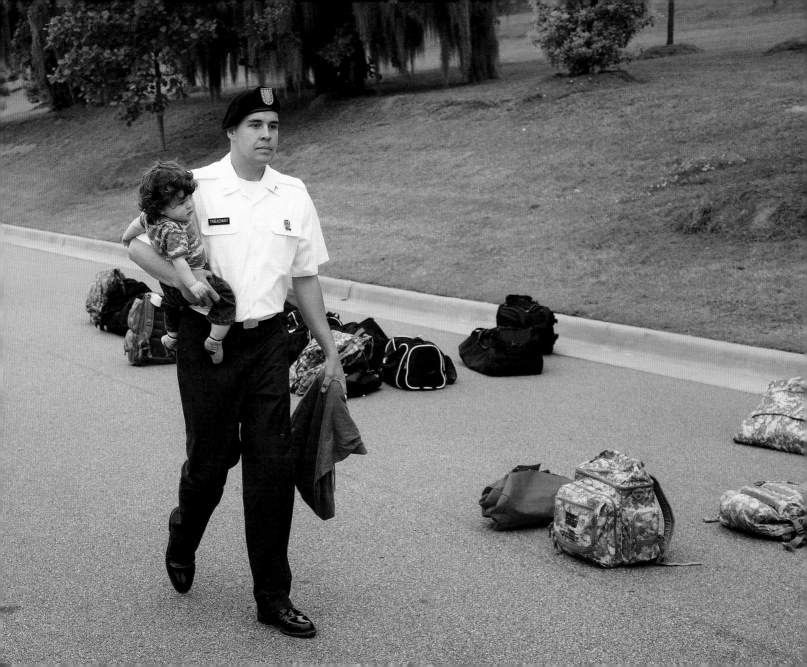

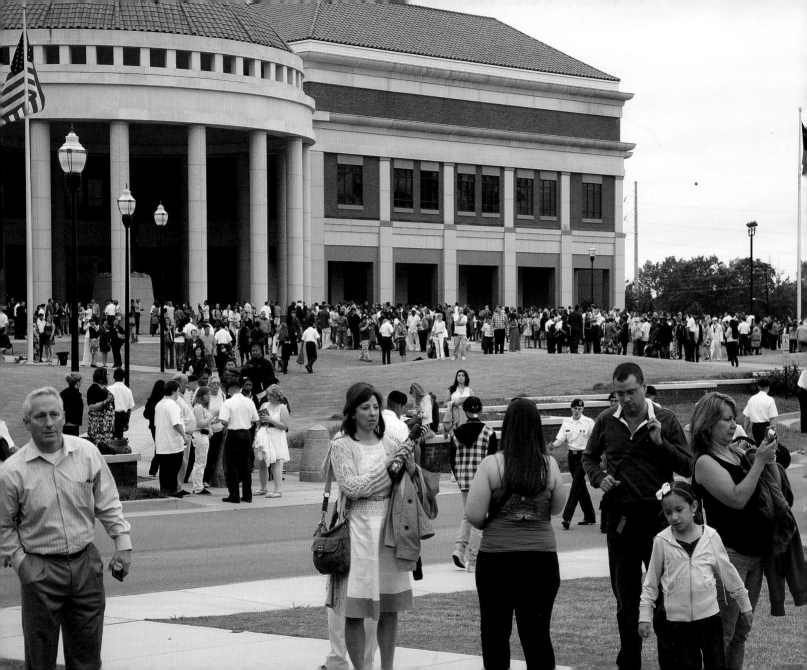

Recruits and their families
socialize outside the
National Infantry Museum.

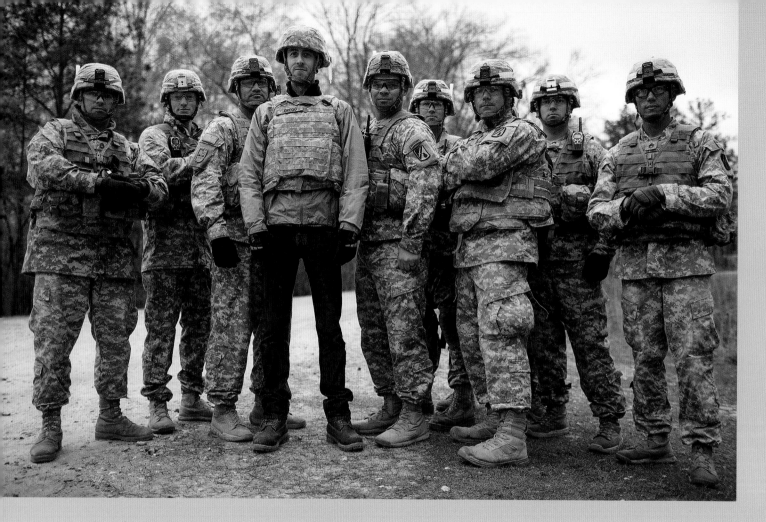

The author Raymond McCrea Jones, center, is surrounded
by the drill sergeants of Delta Company 2/47 near the end of the
basic training cycle.

ACKNOWLEDGMENTS

I want to sincerely thank those who have helped bring this project to life. Richy F. Rosado of the Fort Benning Public Affairs Office, a former airborne ranger and special forces weapons sergeant, has been with me since the very beginning. He shepherded me through the process of permitting and communicating with top brass at Fort Benning so I could have the access I needed. He also accompanied me throughout Fort Benning on many long days and early mornings. Without him this project would not have gotten past the idea pitch.

The same amount of gratitude must also be extended to Lisa Ekus, my literary agent, who guided me through the publishing landscape and fought selflessly to help bring this project to light. And to Marcel Saba of Redux Pictures, who welcomed me into his photographic family and has been a mentor and inspiration to me. Picture editor Brett Roegiers was by my side as we sorted through the thousands of images to craft the visual narrative we have arrived at in this final body of work. Thank you, Brett.

I also want to sincerely thank Capt. Donnie

Bradford, the company commander, who not only tolerated my presence while leading his company but also went out of his way to accommodate me. I must also thank all the drill sergeants of Delta Company 2/47 and 30th AG Reception Battalion for welcoming me into their world for a short time and answering all my elementary questions, especially 1st Sgt. Timathy Bevis who helped with the book well after my time at Fort Benning was done. Lastly, I must thank the 162 soldiers of Delta Company 2/47 for being a part of this project. Although it was only by chance that I was assigned to their company out of the entire operation at Fort Benning, I couldn't have asked for a better lot to photograph over and over again for ten weeks. I think of these men often as I wonder which country they are now stationed in and how they are adjusting to their new paths. I wish them safety, happiness, and the best of luck.

Finally, I must thank my own personal family, who believed in this idea and continue to believe in me. They tolerated my absence, my filth, my exhaustion, and my excitement during this time. For their love and support I will always be humbled and thankful. And to my mother and father, thank you for not having a preconceived idea of what I should be as an adult and for allowing me to follow my passion. Thank you.